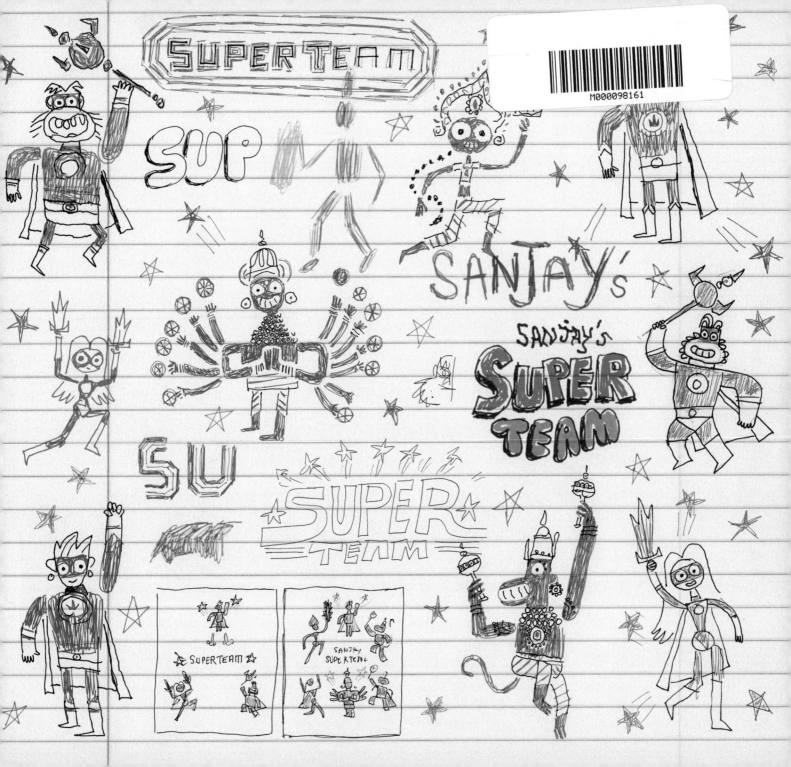

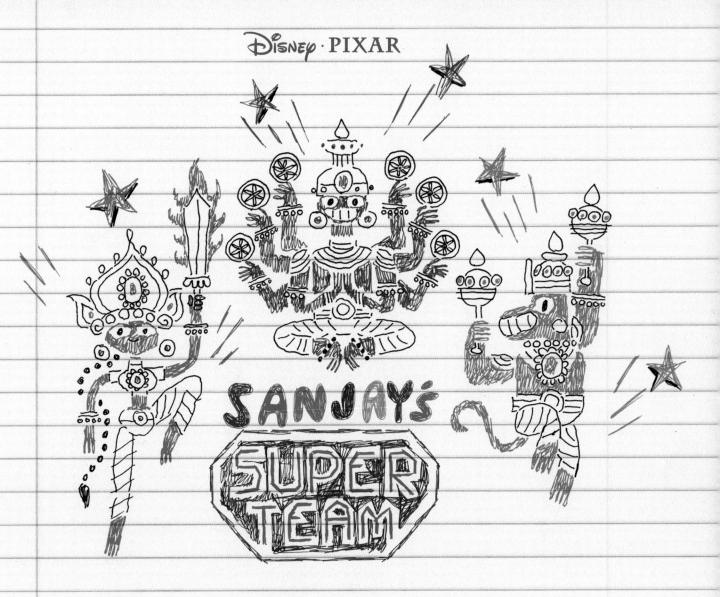

By Sanjay Patel

Foreword by John Lasseter Preface by Chris Sasaki

CHRONICLE BOOKS

SAN FRANCISCO

Library of Congress Cataloging-in-Publication Data is available.

ISBN: 978-1-4521-5206-6

Manufactured in China

MIX
Paper from
responsible sources
FSC™ C104723
FSC
www.fsc.org

Designed by Liam Flanagan

10 9 8 7 6 5 4 3 2 1

Chronicle Books LLC
680 Second Street
San Francisco, California 94107
www.chroniclebooks.com

FRONT COVER
Sanjay Patel, digital

BACK COVER
Chris Sasaki (design),
Shelly Wan and Paul Abadilla
(paint), digital

FRONT AND BACK FLAPS
Jeff Pidgeon, marker

ENDPAGES
Sanjay Patel and Chris Sasaki,
pen and marker

THIS SPREAD
Chris Sasaki, pen and pencil

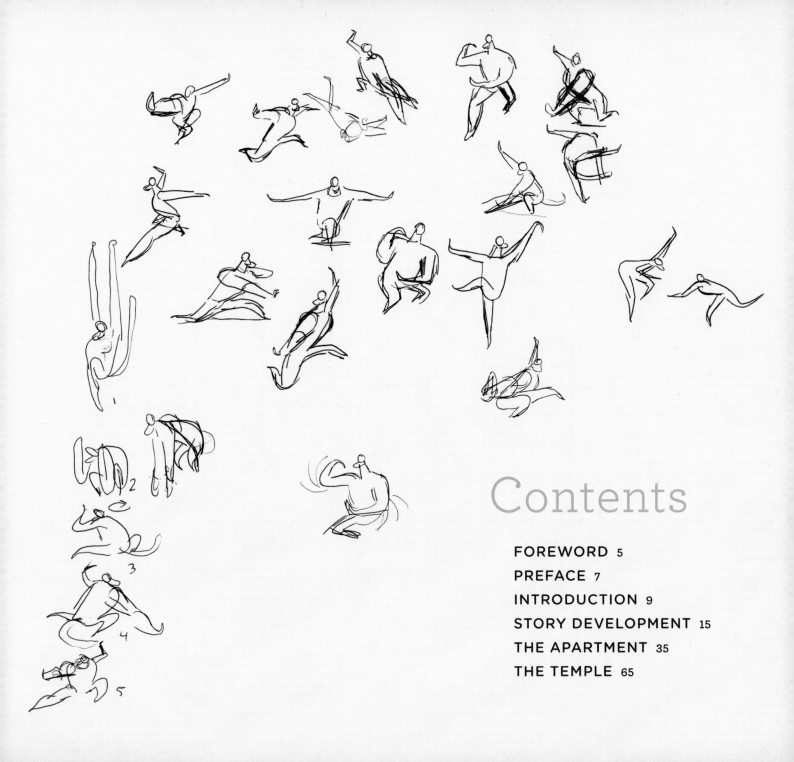

Contents

FOREWORD 5

PREFACE 7

INTRODUCTION 9

STORY DEVELOPMENT 15

THE APARTMENT 35

THE TEMPLE 65

Foreword

JOHN LASSETER

For many years, Sanjay Patel has given dimension and life to Pixar's characters as both an animator and a storyboard artist. At the studio, he helped superheroes fight their way off of island fortresses, taught monsters about scream canisters, and helped toys remind other toys of what's really important in life. Outside the studio, he was refining his exquisite sense of design, creating gorgeous, incredibly appealing illustrations for his stories of Hindu gods and heroes. Two years ago we asked Sanjay to combine these talents and start thinking about ideas for a short film. We were very excited at the prospect of seeing his unique sensibility brought to life on screen.

Sanjay came to us with several great ideas. But the story he told that touched me the most was the one that was the most personal. He talked about growing up with his father, watching his father pray at the altar in their living room as he himself sat across the room in front of the television, watching Saturday morning cartoons. As Sanjay jokingly put it, each of them was practicing his own form of devotion.

Like many of the best stories, it was both very personal and universally relatable. The parents and children in a family are often interested in very different things, and the generational divide can sometimes seem insurmountable at first. But if you're lucky, and both sides are willing to take the time to understand each other, you often find that the roots of seemingly different passions come from the same place. In this way, differences within a family can actually be the catalyst for a much greater closeness than you would ever have expected.

Visually, *Sanjay's Super Team* ranges from some of the most fantastical, stylized imagery we've ever done at the studio, to the most literal and personal—the photographs of Sanjay and his father in the end credits. Because this is the most personal telling of someone's life we have ever made, it seemed only fitting to specially acknowledge the story's roots.

I'm very excited we can share the beautiful art of this short film—and the beautiful story behind it—with you in this book.

Sanjay Patel, colored pencil, pen, and watercolor

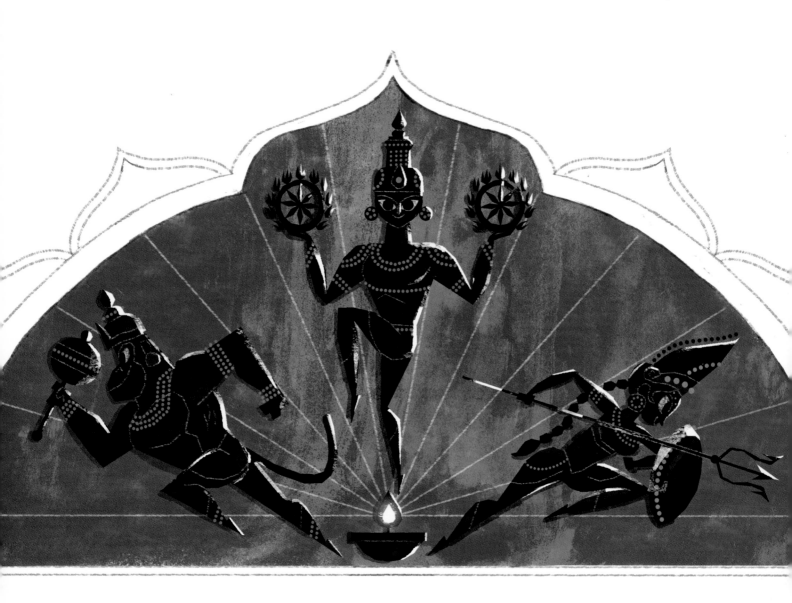

Preface

CHRIS SASAKI

I remember the day I first learned about the project that would eventually become the short film called *Sanjay's Super Team*. I had only met Sanjay once or twice, but I knew his work and was a fan. The tiny room where we met to discuss his project was filled to the brim with images. Photographs of Indian temples and sculptures mingled with storyboards and cartoon superheroes. Sanjay pitched me a very early version of the film, which he had storyboarded himself, and I was instantly hooked. I found myself holding back tears as I realized the film echoed parts of my own childhood experiences as an Asian American. I felt the story came from something true and honest, and I wanted to be a part of it.

After his pitch, Sanjay gestured toward the temple photographs on the wall and flipped through the reference books on the table, explaining that every detail had a purpose and a story. "Look," he said, "I can't expect you to know everything. But I need you to understand how important it is to preserve and give tribute to this mythology and culture." For a first-time production designer, this was a daunting task. Indian culture is vast and ancient. The visual scope of our film was ambitious. The narrative was extremely personal. And everything needed to fit neatly into less than eight minutes of screen time.

Critical challenges appeared at every turn, but the film was a true privilege to work on. The world of *Sanjay's Super Team* blends so many exciting elements—traditional 2D and 3D animation, alternate realities, ancient temples, deities, cosmic action sequences—with a contemporary story about family, identity, and tradition. Visually, we wanted to integrate the ancient themes with a modern perspective. Each design decision, from props to color, was made through the lens of Sanjay's personal story and cultural narrative.

The ideal environment for filmmaking is one of discovery, and *Sanjay's Super Team* provided that in spades. I realize now that my childhood education offered very little exposure to Indian culture and mythology. I am grateful to have learned so much more about it through the making of the film. This journey would not have been possible without the collaborative efforts of our amazing crew. Our team was small, which meant that each stage of production required crucial contributions from individuals. Technical artists, animators, and designers all came together to make something compelling and new. I hope those who see the film, and who flip through these pages, can share in the inspired experience we had while making it.

Chris Sasaki, digital

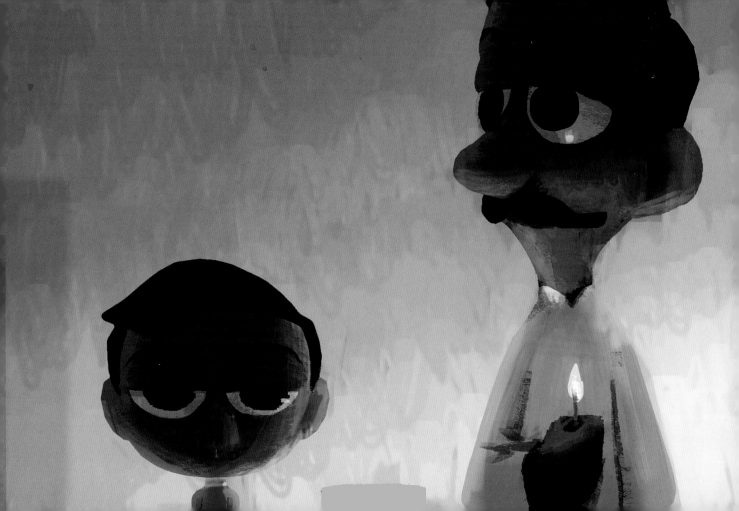

Introduction

FINDING MY SUPER TEAM

After seventeen years at Pixar I had reached a crossroads. I'd spent the last ten years working by day as an animator and storyboard artist. Then, by night, I wrote and illustrated picture books. I knew I couldn't keep doing both jobs. My focus was split and it was beginning to show. Something had to give.

This time of dual careers started while I was storyboarding on *The Incredibles*. A group of us at the studio decided to self-publish comics under the moniker Afterwerks. My effort wasn't exactly a comic book—it was a picture-book glossary of Hindu gods with short descriptions of their mythology called *Little India*. It immediately struck a chord with fans. Suddenly I had a second job creating and selling books, prints, and T-shirts. Eventually, I began working with museums, publishers, and teachers who were all clamoring for the same thing: an accessible introduction to Hindu mythology.

After ten years of this I was feeling burnt out and in need of a change—I decided it was time to focus on my personal work. Once I announced my intentions to leave, however, the president of Pixar pitched an idea that I had never really considered. He sat me down and asked me if I'd like to develop a short. I told him that I wanted to tell stories from my parents' culture, but that they didn't seem compatible with the Pixar brand. To my surprise, he said that something different was exactly what the studio should be doing. He added the caveat, "You won't get your vision entirely. If you can live with some compromise, then we can help tell your story." I was stunned that they were willing to explore mythological material. As for the notion of directing something at Pixar, well, that just stirred up so much fear within me. I felt safe developing my personal work in private, and having free rein to explore ideas according to my taste. I knew the story and filmmaking process at Pixar could be brutal, with everyone trying to tear down your material in order to rebuild it in a better way. It was scary to think of opening myself up to this process with work that was, well, personal. It seemed risky to mix the two worlds together. After much thought and many conversations with friends and colleagues, ultimately what tipped my hand toward undertaking a short film project with the studio was a conversation I had with my dad. He said that the company had taken care of me for nearly twenty years, and to walk away without attempting to do what they were asking would be bad. He said my duty was to try. And with that my two jobs became one.

Paul Abadilla, digital

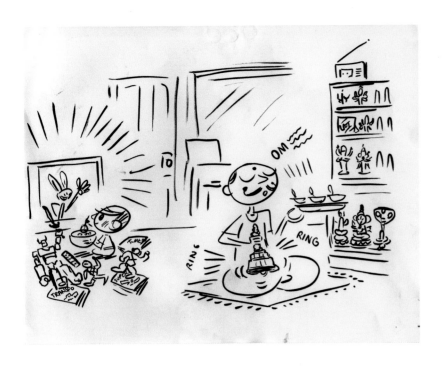

I pitched four concepts to John Lasseter. In the end, he didn't pick any exactly as I'd pitched them. Instead he zeroed in on a drawing from one of the pitches that illustrated how I grew up with my father, and how we both had our respective forms of devotion and the culture clash it created. Straight away he connected with it. John never paused on the question of religion and how that would play out in a Pixar film. He believed in this part of my childhood, having felt similar conflicts during his own. As we delved further into this concept, he kept encouraging me to make it personal. He suggested naming the short after me. He also asked how I would feel if we showed photos of my dad and me over the credits. Material that had always felt personal became even more so; in the end it became a love letter to my father. In hindsight, opening myself up and facing my fears was met with nothing but respect and support, especially from John.

From beginning to end, he was the biggest champion of the short. Instead of tearing things down, he taught me to dig for my own truth and to have the confidence that it would ring true for others as well.

The irony of this whole experience is that my dad's never seen a Pixar movie. I've never shown him the films I've worked on, or the books I've created, mostly because his way of living in the world does not include American popular culture. The most I've done is open one of my books and read out loud a dedication I'd written to him. He'd smile, half understanding, then quickly get on with life.

My dad is a very busy man. He seems only to be still when he's meditating. When I was a kid, he would make me sit with him during this practice, reciting words and making gestures that bored me to no end. In many ways, it was the last place I'd willingly return to. And yet I did. As I worked on the story for the short,

I realized that in order to understand these events from his point of view, I had to go back to the site of so much irritation in my youth—my father's daily devotional practice. This time I wasn't silent or bored. I approached him with genuine interest and respect. I asked him a number of questions about his faith and his practice. What I learned was different from what I'd read in all the books about Hindu mythology. What I learned was details about my dad. He told me about a promise he had made to his mother to continue the devotional practice that she had instilled in him. He told me that he prayed every day for my mother, who is severely schizophrenic. The daily struggle of his life was made plain as I watched tears stream down his face while he prayed. I felt awkward as he wept. I stopped my questions and gave him his peace. A while later, having thought about our conversation and the deep spiritual and personal connection he revealed to me, I finally understood that my father's devotion is how he supports himself. For close to forty years in America, displaced from his family and his roots, my father's shrine has been his home.

The making of this short film has been an incredible journey that I would not have believed possible even a short time ago. To be able to meld my personal work with the legacy of Pixar is beyond my wildest dreams. My hope is that the film and this book will inspire many "Little Sanjays" to find community in their differences, and to see their parents' culture in a new light.

Photographs by **Sanjay Patel**

TOP Gopalji M. Patel, Sanjay's father,
praying at his home shrine.
BOTTOM The diya and surrounding
deities in the shrine.

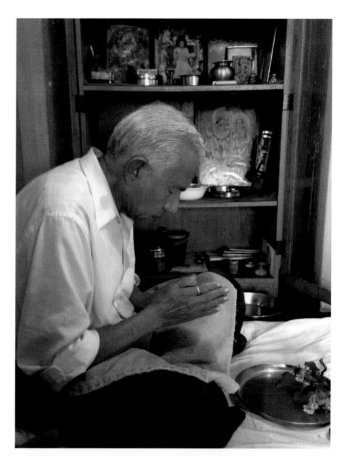

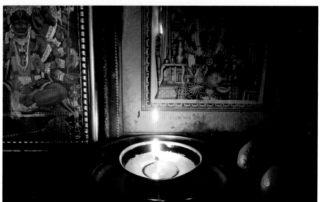

The title *Sanjay's Super Team* was not selected until well into production. We started out with titles that more clearly identified the film as having a Hindu connection, such as "Diya," meaning "lamp" and denoting the theme of light, or "Darshan," meaning "visions of the divine." But John Lasseter told us in no uncertain terms that we had to make sure the film was not religious, but rather a personal story. If the film had the potential to ignite a religious backlash, Disney would shelve it. That got our attention!

As you can see in this cartoon, we all had some ideas about what to call the film, though none of them worked perfectly. After John left us to ruminate, I remembered the action figure in the film saying "Super Team" and that Sanjay considered himself and his dad a "super team." I texted Sanjay this title and it was a done deal.

Well, not really. Dallas Kane, our Production Coordinator, did not like it at first, which caused Sanjay to worry about it. She thought it sounded like a kid's book. After he discussed it with Dallas a few days later, she suggested that "Sanjay" could be hand-written over the finished Super Team logo. That's when Sanjay finally embraced it. I always liked it because it sounded to me like a film a kid would want to see, while the name "Sanjay" suggested something Desi, something a little different than the standard superhero story.

NICOLE PARADIS GRINDLE, PRODUCER

Sanjay Patel, digital

1. after the review with John he took off for another meeting with Andrew. Nicole and I ~~stayed~~ stuck around after everyone left talking about the review. this was probably a good 30 mins later. And low and behold JL actually came back to look for us.

JL!

2. I was thinking about the title and wanted to ask you guys to try thinking of a title that described the film a bit more

3. may be ~~not try a~~ try a title like "Sanjay and his new comic book"

4. or how about "Sanjay's Superheros"

5. work on it.

Thanks John

Yeah man thanks!

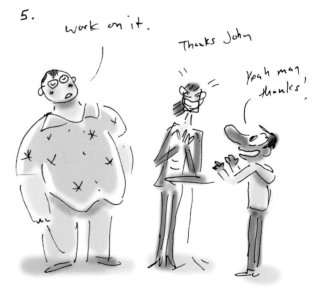

Story Development

JUST TELL YOUR STORY

The story I told John Lasseter was my own. I told him about how my father and I had our own rituals, and how it took me thirty years to realize how similar they were. Every morning I would sit down with a bowl of sugary cereal, mesmerized by my cartoon idols on TV. Beside me, my dad sat like a statue gazing at his gods, colorfully anointed and displayed in his shrine. We both were devoted and reverent, just to different things and in different ways. The frustrating part was how long it took for me to see what my dad was seeing. It's this awakening and appreciation that I wanted to dramatize with the short. This did not turn out to be a simple task, since everything about my dad's practice and religious philosophy defied instant understanding. In less than five minutes, and with no dialogue, I had to figure out how to make the world of my father's Hindu practice accessible to audiences around the world. In addition, getting the motivation and journey of the boy just right took a seemingly endless amount of trial and error. Most of our story breakthroughs came from John, of course. The analogy of superheroes and villains and gods and demons took us much of the way toward how a child might connect these two worlds. Then the anecdote John related about being bored in Sunday school and trying to get out of it was the key to the rest of it. By the end, I realized that I didn't need to explain an entire culture—if people come away from the film with questions about the deities or Hinduism in general, hopefully they will be inspired to do some research on their own. What I hope people are left with is a glimpse of what I saw when I began looking into my dad's world, and how it wasn't so different from my own, and how this discovery ultimately brought us closer.

Sanjay Patel, pen and colored pencil

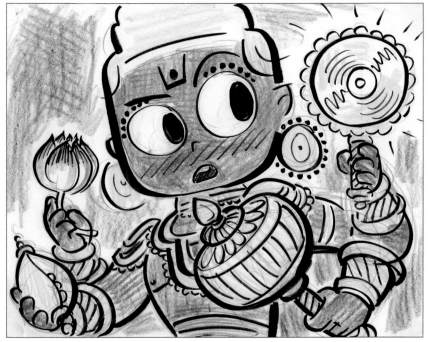

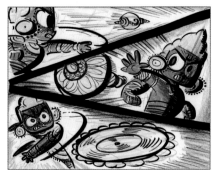

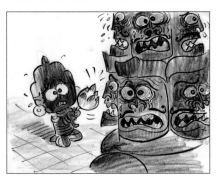
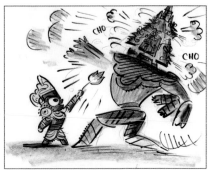

We were lucky enough to bring a banner from Sanjay's exhibit at the Asian Art Museum in San Francisco to Pixar's campus. John Lasseter took one look at it and said, "I want to see Sanjay's art come to life!" As I worked closely with Sanjay, developing some early ideas, his drawings for a short called *Temple* grabbed me right away. *Temple* follows a boy who guards shoes on the steps of an Indian temple. He's so engrossed in his comic book that he ignores the ornately carved panels surrounding him. Desperate to buy the next comic book, the boy steals from the temple's donation box. His crime awakens a statue of Vishnu, who transports him inside one of the temple's carved panels. The boy transforms into a deity and has to leap from panel to panel, fighting a demon. When he is zapped back to reality, he finally sees how kick-ass the stories in the panels are. He bows to Vishnu, who smiles and returns his comic book. The film Sanjay ultimately made starts in a completely different world, but the heart of the story remains the same.

MARY COLEMAN,
CREATIVE DEVELOPMENT EXECUTIVE

Sanjay Patel, marker, pen, and colored pencil

Making films is hard. Things become chaotic and messy, which is just part of the creative process. Still, a filmmaker can get a bit lost and wonder if what he's doing has any worth, or if the story even makes sense. And at times the creator can find himself in a rather dark place.

Sanjay shared his troubles with me during one of these moments, and upon reflection, I basically told him that he already had the answer. His film is all about the symbol of light—the flame. It's such a simple, universal image, and it says so much.

There's a father (Dad) who wants to share the stories of his culture with his child (Little Sanjay). The father goes about it the only way he knows how, which, unfortunately, the son does not completely understand. It isn't until the light goes out that the child gets a glimmer of the light's greater meaning, and realizes that he needs to either restore life to the flame or remain in darkness.

In a funny way, this metaphor also speaks to the creative process. The light may go out and things may get dark, but there is always hope if you can reignite that initial little spark where your journey first began.

TONY ROSENAST, STORY ARTIST

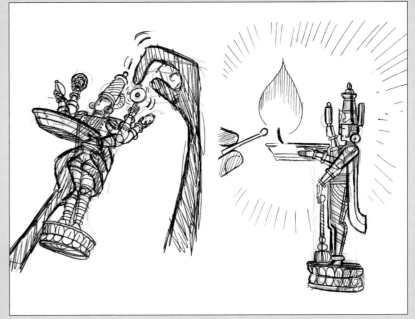

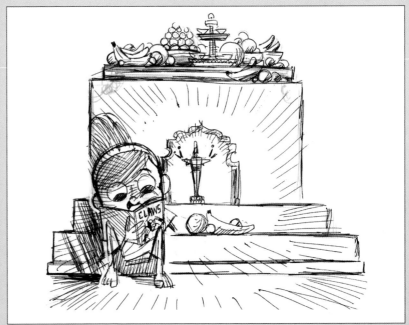

Sanjay Patel, pen and colored pencil

17

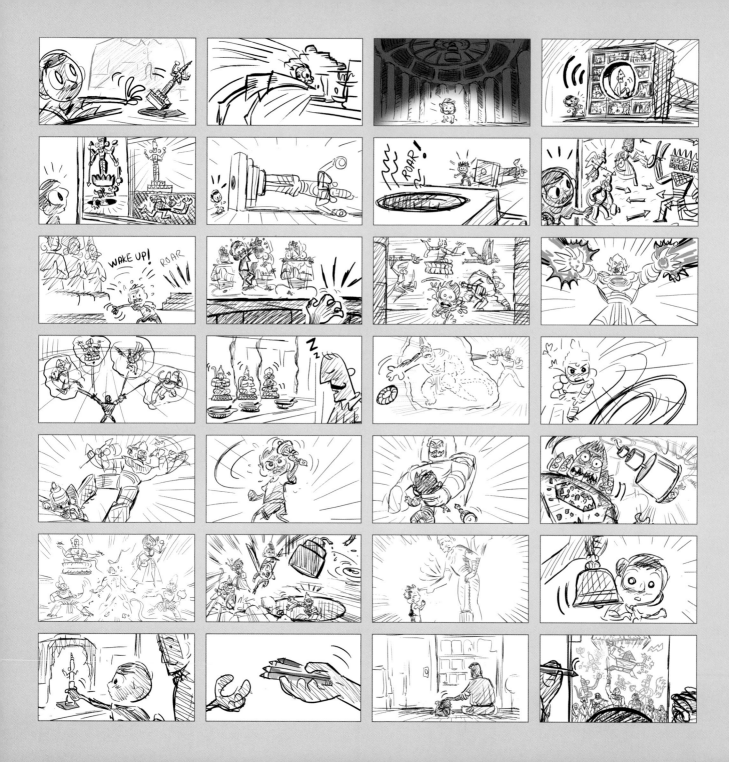

I was very excited to hear that my good friend Sanjay was going to make a short film here at Pixar. I've always loved his personal style, and couldn't wait to see it on the screen! Working on *Sanjay's Super Team* was an absolute joy. Sanjay fully commits himself to a project, and his enthusiasm—usually expressed in a steady stream of joyous, colorful language—is critical to the creative process. Naturally, his talent produced a thoughtful piece with boundless energy and deep beauty—in other words, a very Sanjay film.

Contrast is one of my favorite story elements. I did this drawing to remind myself of a great contrast at the heart of the story—Little Sanjay's energetic play alongside the serene meditation of his father. The story brings the pair together, but the contrast generates conflict and makes it entertaining!

JEFF PIDGEON, DEVELOPMENT ARTIST

RIGHT
Jeff Pidgeon, marker

RIGHT
Sanjay Patel,
pen and watercolor

OPPOSITE
Sanjay Patel, digital

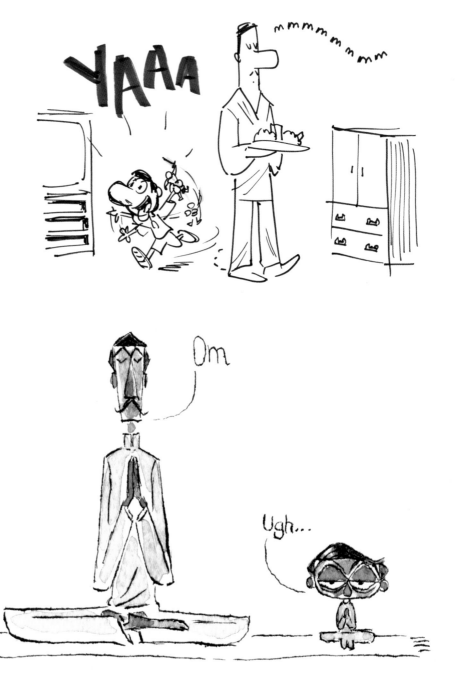

Having spent a decade-plus animating at Pixar, it's always a blast when you get a scene with two characters that is full of pantomime potential. The setup here evolved straight out of my love for *Looney Tunes* cartoons. In those films, one character, usually Bugs Bunny, is virtually static which creates the perfect contrast for the other character, in most cases Daffy Duck, to be animated. All this was in the back of my head as I did these thumbnails—I was having lots of fun milking the moment for as much character animation as possible. Half a year after these were completed, animator Matt Majers was assigned the scene. He never saw these thumbnails, which was for the best as he was able to find his own take on the moment. In the end, what's communicated is a little kid's reluctance to sit through his father's Sunday school.

SANJAY PATEL, WRITER AND DIRECTOR

THIS PAGE
Sanjay Patel,
pen and colored pencil

OPPOSITE
Sanjay Patel, digital

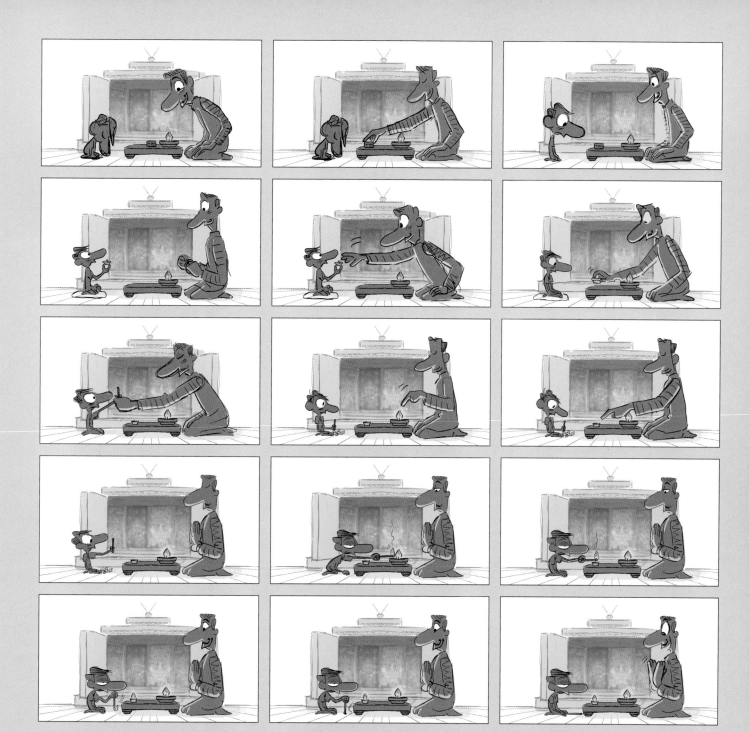

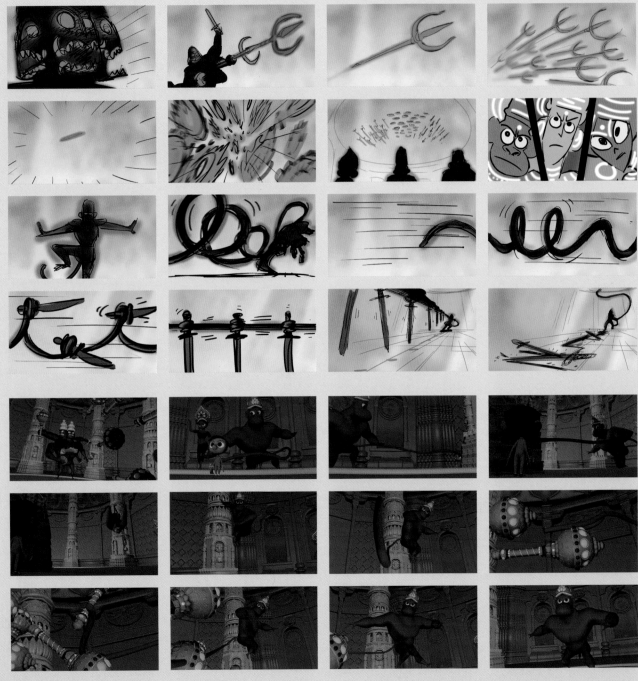

CAMERA EXPLORATION

Nobody does action that's more over the top than anime artists. Since I wanted an epic showdown between the gods and demon, I did some research and watched several of my favorite anime cartoons. As I watched, I began thumbnailing the shots—this really helped me get in the right headspace as I began to re-board the action moments.

SANJAY PATEL,
WRITER AND DIRECTOR

OPPOSITE, TOP FOUR ROWS
Sanjay Patel, Tony Maki, and Vlad Kooperman, digital

OPPOSITE, BOTTOM THREE ROWS
Arjun Rihan, digital

RIGHT
Sanjay Patel,
pen and colored pencil

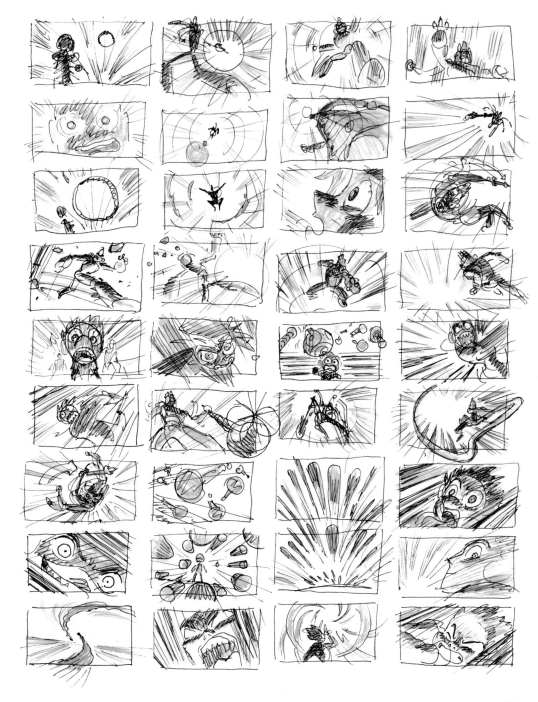

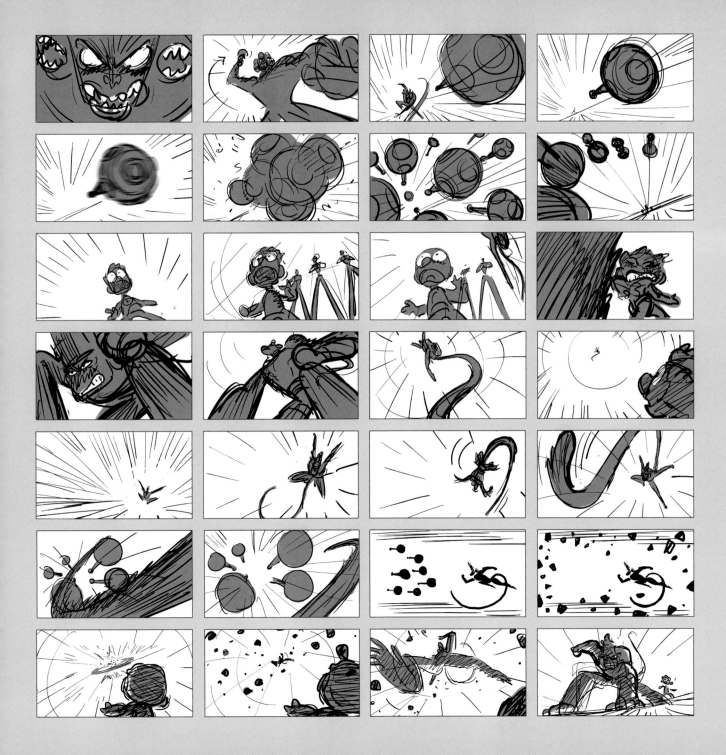

This "location scout" represents early camera and staging work based on Sanjay's original storyboards for the Hanuman attack, and was our first pass at choreographing the action scene in the three-dimensional temple. At this early stage in production, Sanjay's vision for the battle was still evolving, and as we attempted to capture the dynamism that he was looking for, it quickly became apparent that the original dimensions of the temple felt too small—it needed to be much bigger to showcase the epic battle. We decided that the temple could explode to a bigger size when Little Sanjay lit the diya, echoing the cosmic themes in the film.

In addition, an important staging change reflected in the location scout is that Little Sanjay stands close to the gods during the battle. In the storyboards, he stood by the diya at the center of the temple. We made this change in order to visually unite Little Sanjay and the gods into a "Super Team" at the eastern end of the temple.

ARJUN RIHAN, CAMERA SUPERVISOR

OPPOSITE
Sanjay Patel, digital

RIGHT
James Campbell, digital

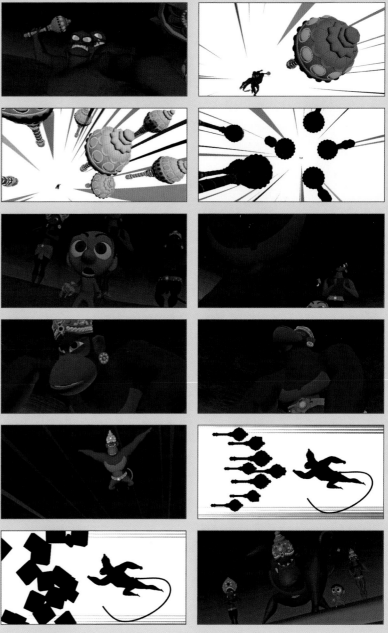

FINAL LAYOUT

25

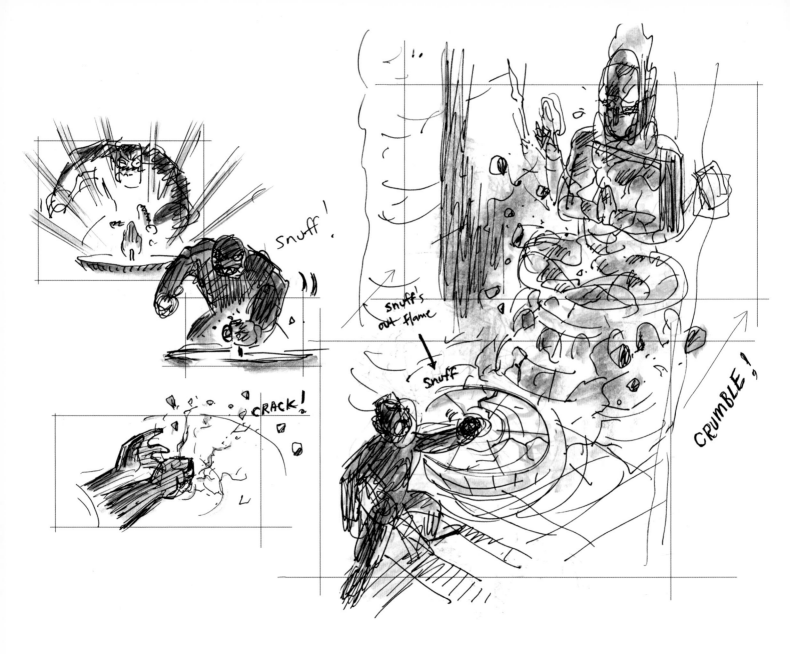

Sanjay Patel,
pen and colored pencil

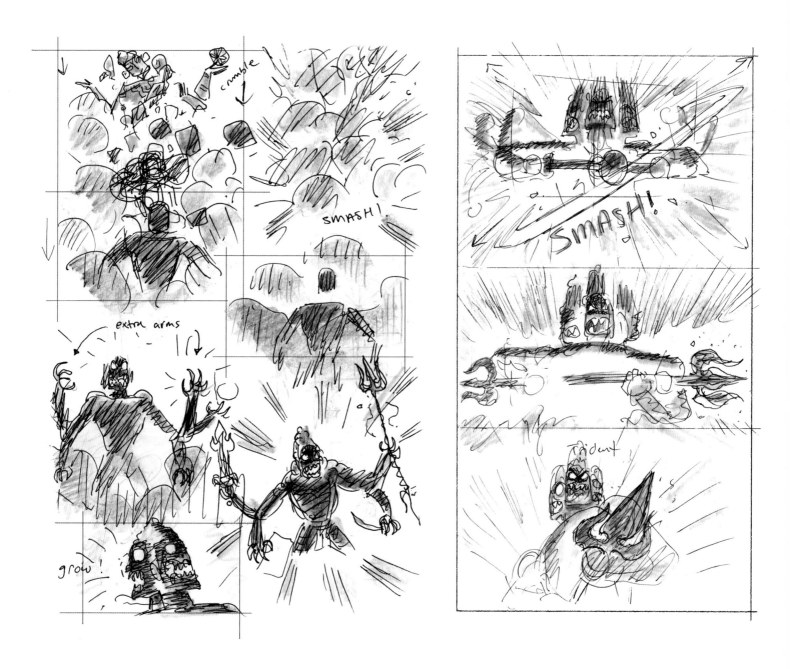

Shattering your idols was a big idea for me. The execution of this moment in the short is, well, very short. If we'd had a bit more time we could have shown more clearly that once the boy's idol is shattered, so is his problem. When I pitched this moment to John, he liked that the bad guy was not violently vanquished. He really responded to the notion that all it takes to change from bad to good is an awakening. The symbolism rang true for me personally as well. All throughout my art education I held firmly to my Western and European art idols. I thrived on this canon until I'd exhausted it as a source of inspiration. It really took taking a break from European art—letting go of those idols—for me to open the door to Asian art and history, where I found renewed inspiration.

SANJAY PATEL, WRITER AND DIRECTOR

Sanjay Patel,
pen and colored pencil

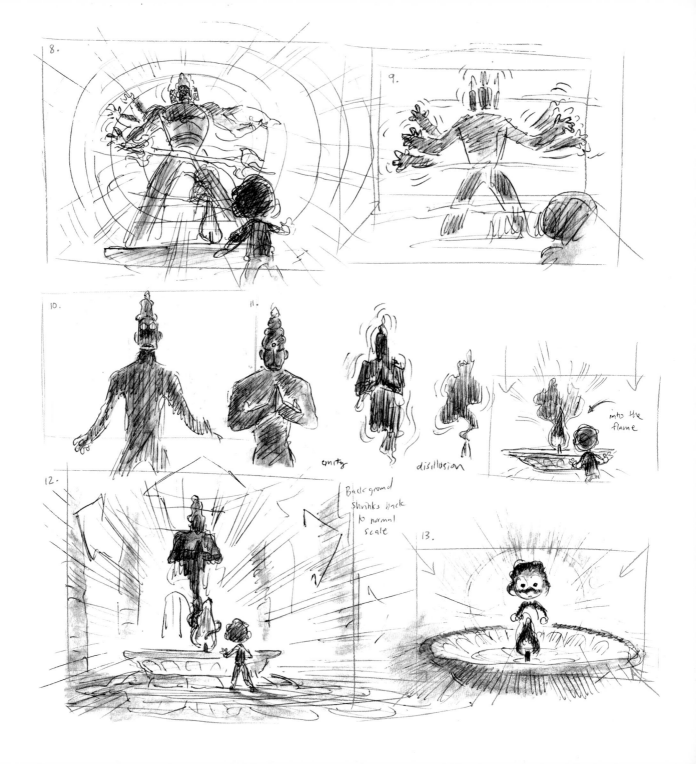

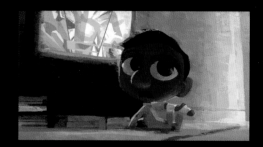

Paul Abadilla, digital

The color script provides a guide to the way we cinematically tell our story with the use of light and color, in support of the emotions that we want our audience to feel. The color script was never a one-shot thing: as the story evolved during production, so did the color script. Consequently, these paintings had to be done small, fast, and loose, while retaining clarity. The quest to solve the many unknowns, including how to show the evolution of the relationship between Dad and Little Sanjay, and how we could visually portray the entirety of Act 2, all started in the color script.

PAUL ABADILLA, LIGHTING DESIGNER

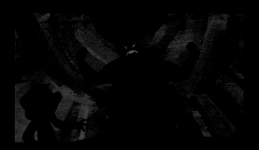

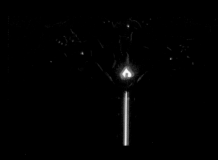

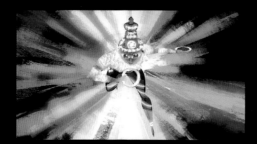

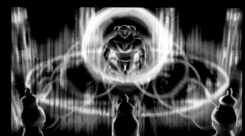

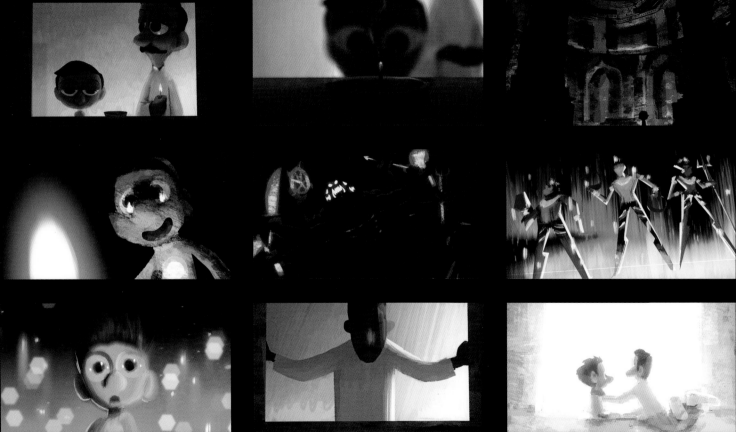

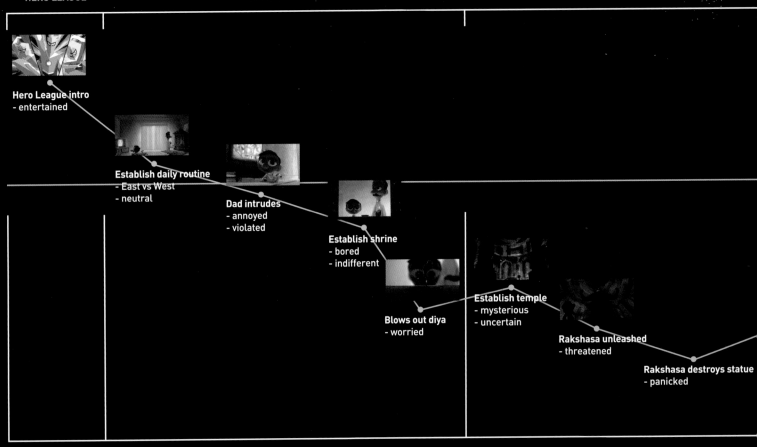

Hero League intro
- entertained

Establish daily routine
- East vs West
- neutral

Dad intrudes
- annoyed
- violated

Establish shrine
- bored
- indifferent

Blows out diya
- worried

Establish temple
- mysterious
- uncertain

Rakshasa unleashed
- threatened

Rakshasa destroys statue
- panicked

ACT 1

Paul Abadilla, digital

A lot of thinking goes into creating a color script. Orchestrating the proper use of color, value, saturation, temperature, and contrast greatly affects the emotional content of any given scene. This road map provided a platform to organize my thoughts, and also helped communicate my ideas to Sanjay and the technical artists. Color association became a useful tool in tracking these ideas throughout the film. For example, making a connection between the Super Team and the deities was important, so we assigned them a wide color spectrum; however, the color purple was reserved for the villain. Moreover, the neutral and earth-toned apartment not only indicated undertones of the mundane, but also amped up the more vivid and fantastic moments inside the temple.

PAUL ABADILLA, LIGHTING DESIGNER

TEMPLE

APARTMENT

East meets West
- unity and harmony
- uplifting

Action sequence begins
- excited
- amped / adrenaline rush

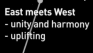

Rakshasa is awoken
- relieved

Enlightenment
- humbled
- dreamy

Reveal deities
- astonished
- surprised

Sacrifice
- brave
- optimistic

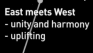

Dad gives up
- back to normal
- mundane
- contentment
- failure

Temple doors
- Sanjay figures out
 how to solve problem
- 1st sign of enlightenment
- hopeful

**Rakshasa destroys
another statue**
- chaotic

**Rakshasa's complete
transformation**
- hopeless

ACT 2

ACT 3

33

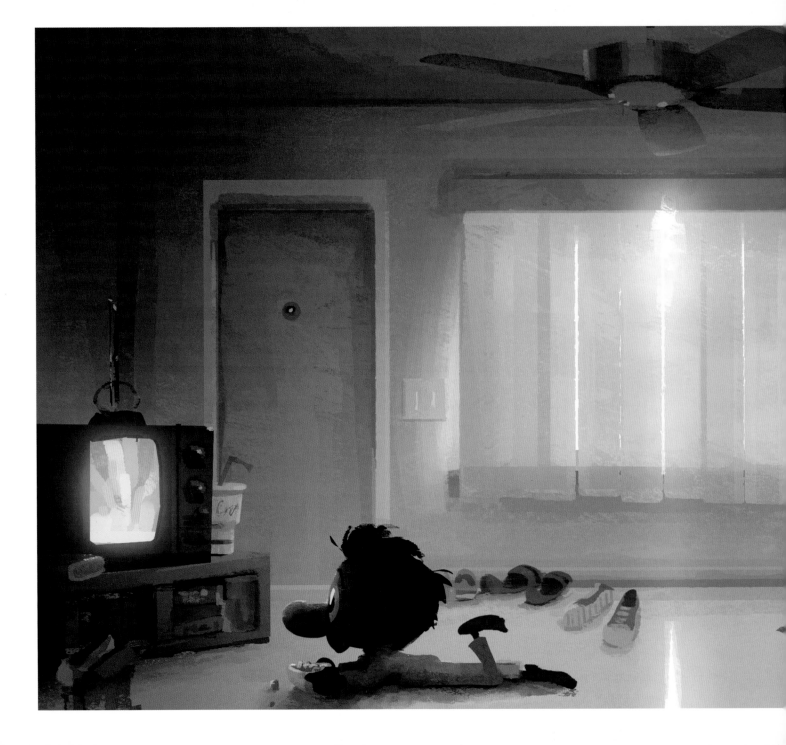

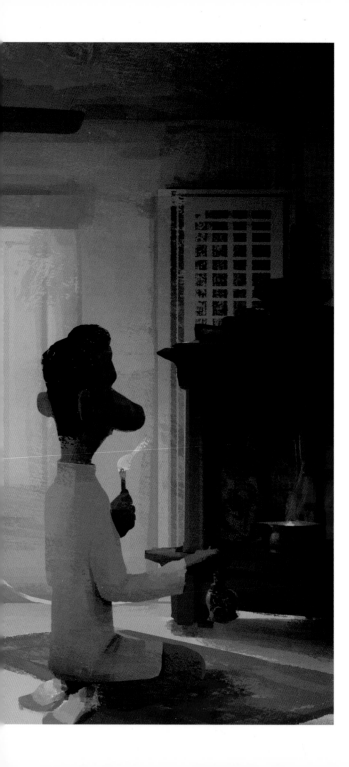

The Apartment

EAST VS. WEST

"Beige on beige" was a key phrase that production artist Kyle Macnaughton came up with in reaction to the apartment. We needed it to feel utterly boring and lifeless in order to contrast with the temple. Contrast drove every design decision, since the clashing of two cultures was at the root of our story. We literally mapped America and India onto the west and east of the screen. Everything American was with the boy on his side of the room. Conversely, everything that was from India was with the dad on his side. We wanted the room to show the two very different lives that immigrant children and their parents can live within the same walls. I was thrilled when extraordinary digital painter Robert Kondo synthesized all of these big ideas into a painting that had lots of striking detail. In particular, Robert included a shaft of light escaping from the blinds that divided the room and became the border between the two worlds. It was the perfect microcosm for the short's culture clash.

Robert Kondo, digital

At the beginning of the film, the light coming through the shades divides the apartment into two spaces. By the end of the film, the light opens up to create a space for two generations of family, father and son, to meet and find common ground.

This story is Sanjay's story. We wanted to capture his memory of a Saturday morning growing up as "Little Sanjay" in the Inland Empire area of Los Angeles. As designers, we wanted to uphold Sanjay's vision and add to the richness of it through research. Being non-specific with these moments felt like betraying the deeply personal experience and passion he was sharing with all of us. We hoped to capture the world in his head and heart.

ROBERT KONDO, DESIGN CONSULTANT

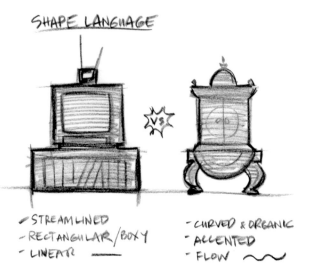

ABOVE
Paul Abadilla, pencil

RIGHT
Paul Abadilla, digital

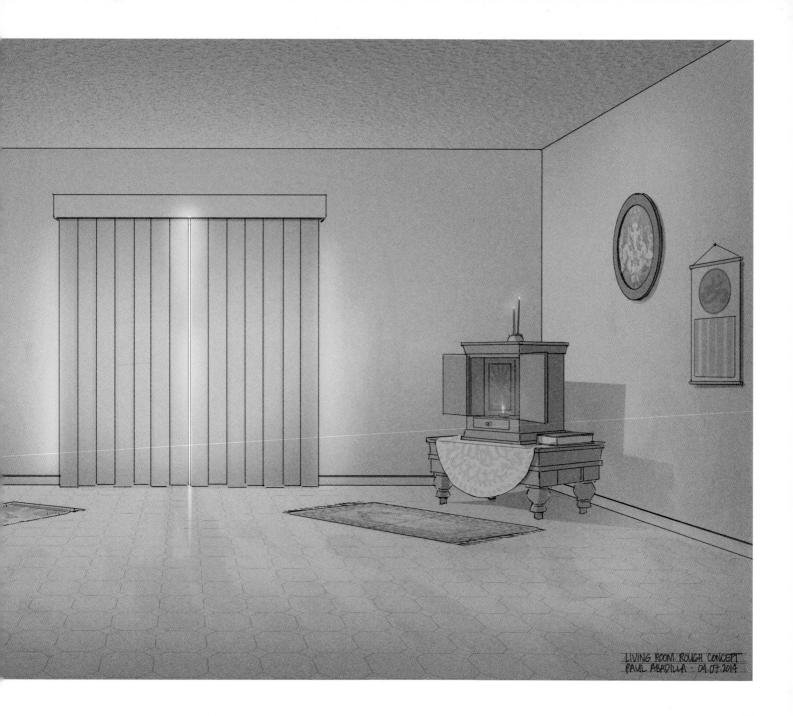

LIVING ROOM ROUGH CONCEPT
PAUL ABADILLA · 04.07.2014

37

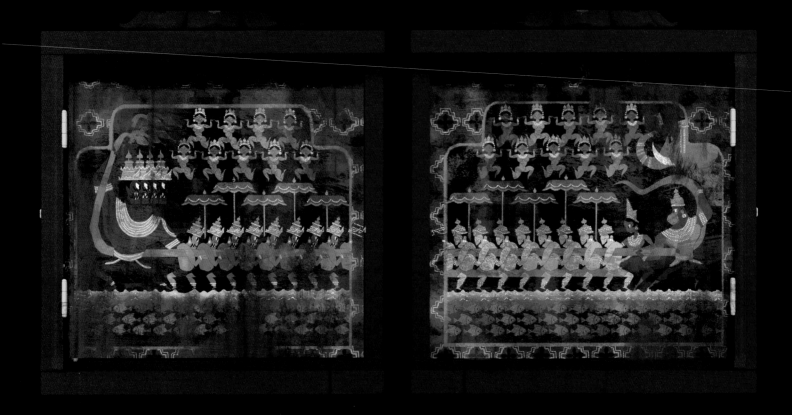

**Chris Sasaki (design), Shelly Wan
and Paul Abadilla (paint),** digital

The shrine and diya played a big part in the story, acting
as a sort of gateway to Little Sanjay's Eastern culture. All
of the surface details foretell the dreamlike sequences that
occur later in the film. We also wanted to contrast the look
of the shrine with the TV. The light of the shrine is calm
and natural, while the TV is vivid and artificial. The shrine's
wood and paint were designed to feel aged and unique
compared to the TV's generic manufactured appearance.

CHRIS SASAKI, PRODUCTION DESIGNER

The mural that graces the inner walls of the shrine is
inspired by the Hindu myth of the Churning of the Ocean
of Milk. The cosmic tug of war between the deities and
demons seemed like the perfect backdrop for the father/
son culture clash.

WRITER & DIRECTOR, SANJAY PATEL

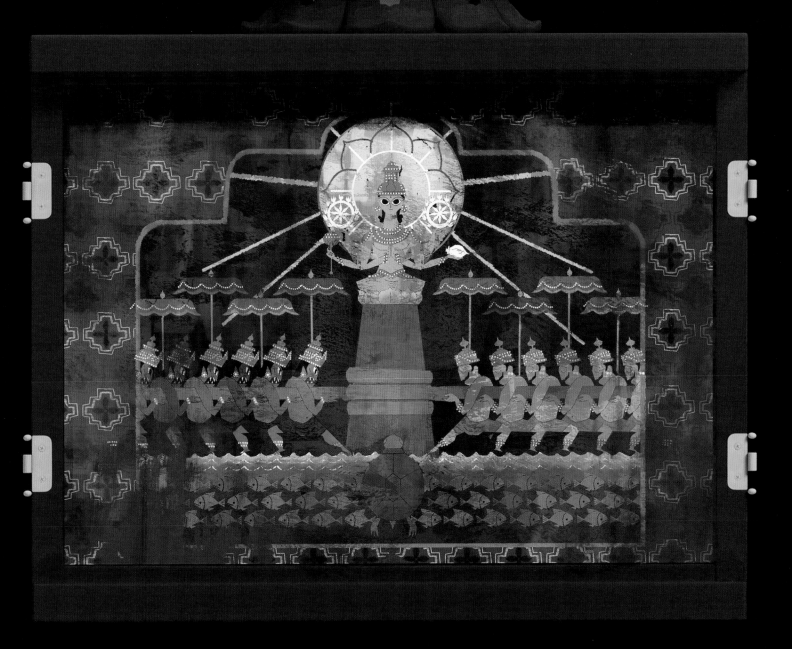

These are very early character designs, probably done one year prior to the actual pre-production. When Sanjay came and asked me to do some exploration for his short in 2013, I was quite surprised. Sanjay is an amazing artist and a master at designing stuff. I remember he wanted more square shapes for Dad and "NO big nose" for Little Sanjay [which the real-life Sanjay does posess]. I am glad he eventually relented—Sanjay and Chris came up with outstanding designs.

KRISTOPHE VERGNE, CHARACTER DESIGNER

THIS SPREAD
Kristophe Vergne, digital

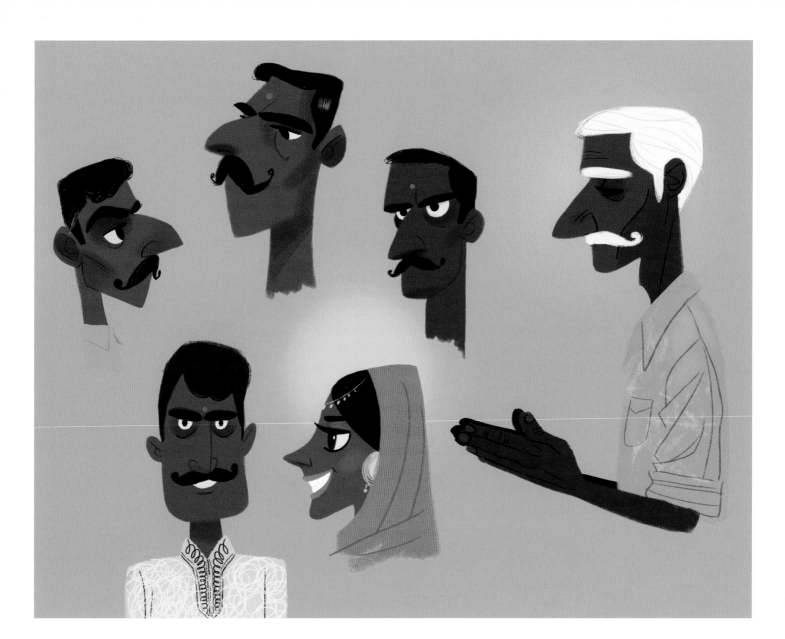

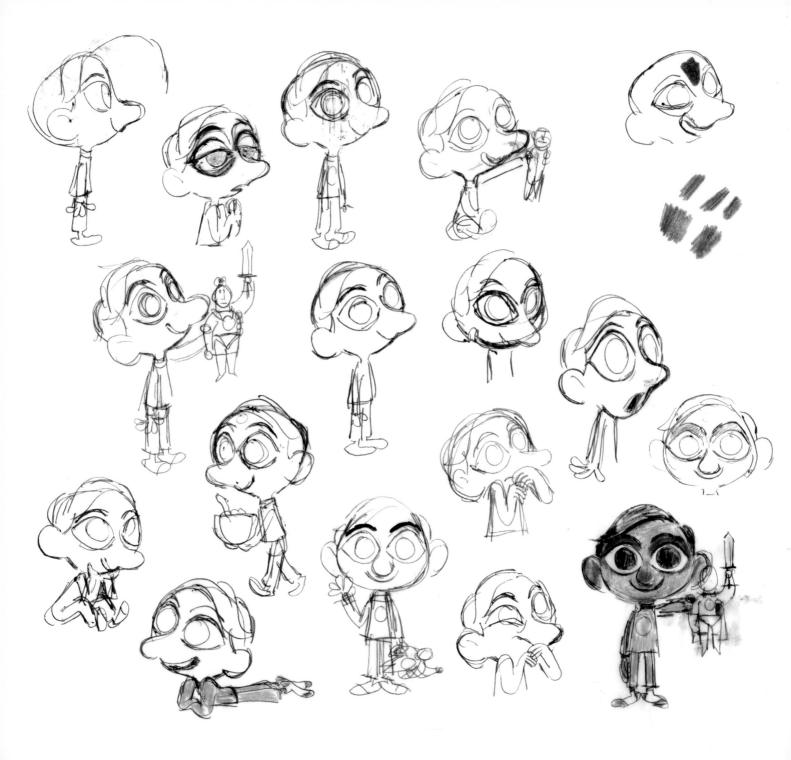

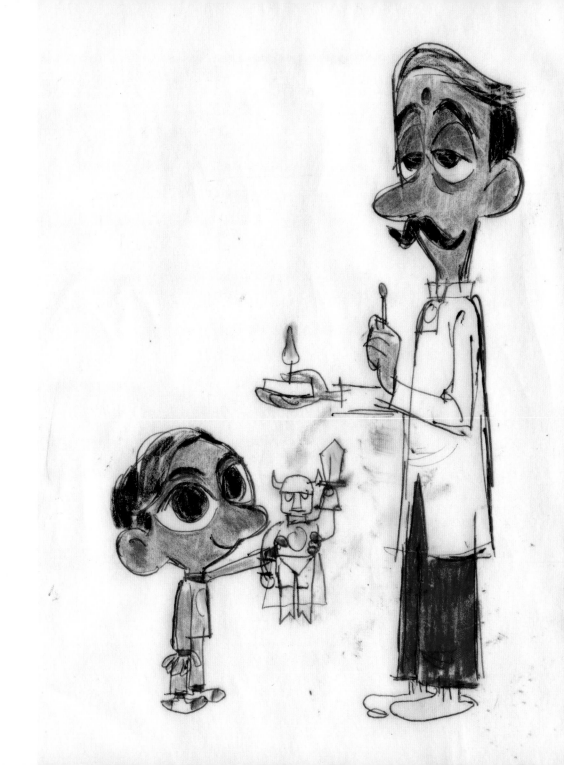

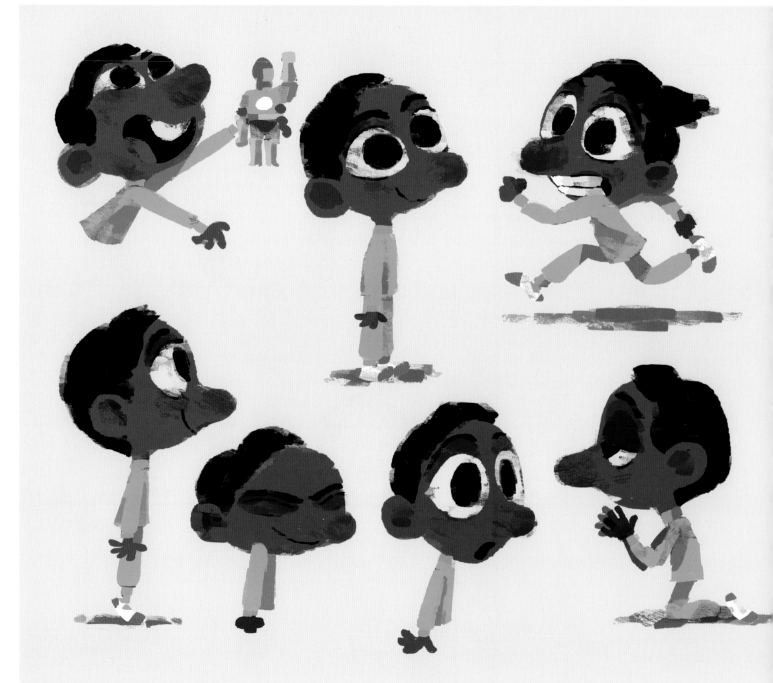

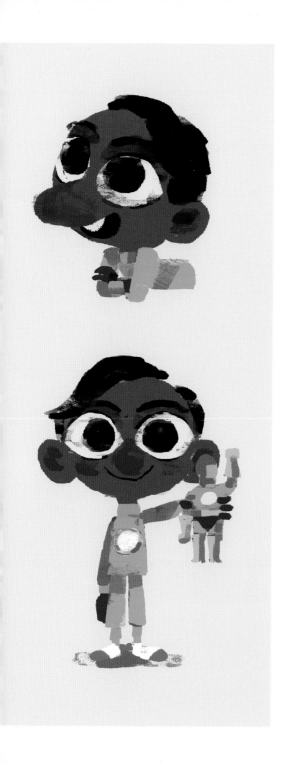

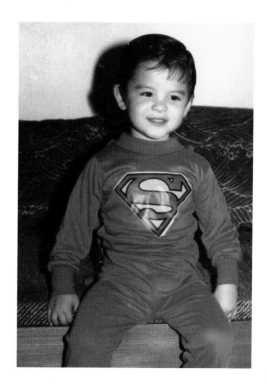

ABOVE
Photograph by **Dennis Sasaki**

LEFT
Chris Sasaki, digital

Like Little Sanjay, my morning ritual as a child consisted of eating cereal with my face glued to cartoons on TV or inside comic books. While working on the film, my dad shared an old photo of me in Superman pajamas that sparked an idea for Little Sanjay's design. We decided his pajamas should feel like they came from American superhero culture, but share the same colors as Vishnu to connect Little Sanjay visually with the Eastern motifs in the film.

CHRIS SASAKI, PRODUCTION DESIGNER

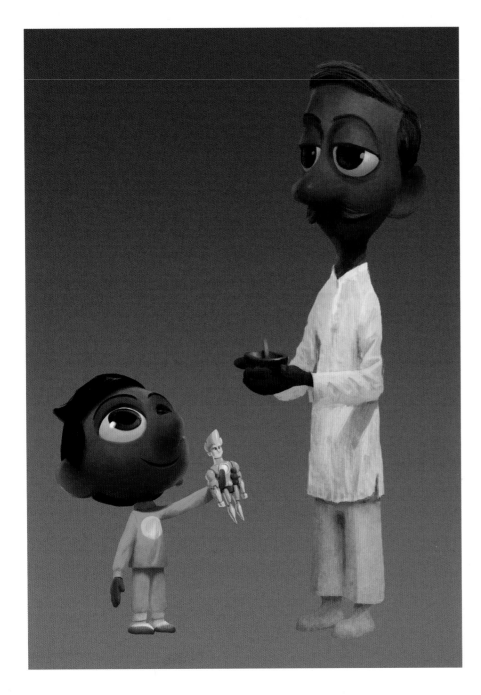

My role was to help from the outside through mentoring Paul Abadilla to complete the color script of the film. I think Paul did an incredible job working closely with Chris and Sanjay.

DICE TSUTSUMI, DESIGN CONSULTANT

LEFT
Dice Tsutsumi, digital

OPPOSITE
Sculpts by Greg Dykstra
Photograph by Deborah Coleman

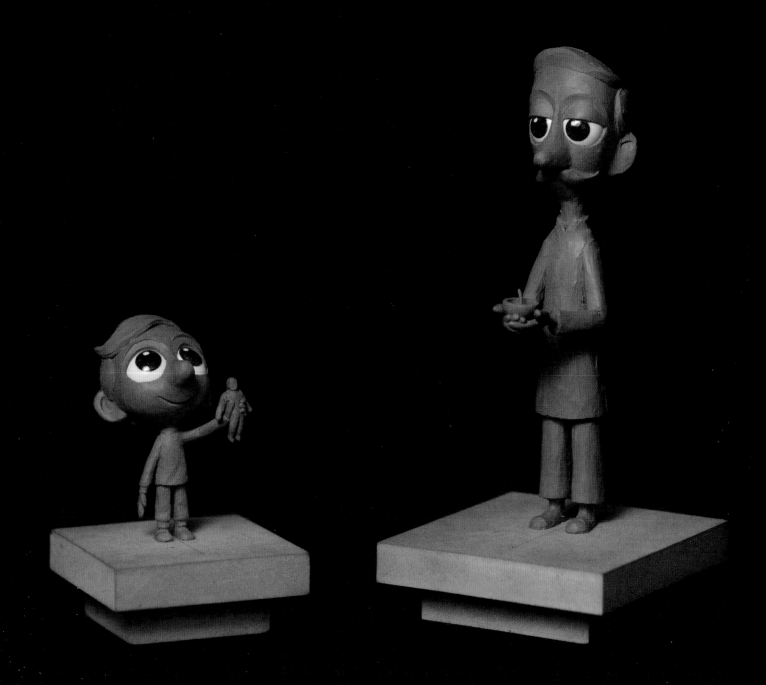

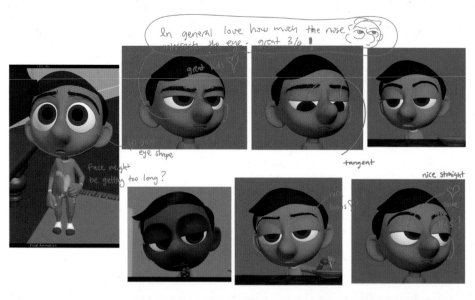

In the early stages of animation, we built a library of face poses for each character that the team of animators could reference in order to help maintain a uniform look between shots. Often times it can be a subtle adjustment to the shape of an eyelid or a slight tweak to the angle of the head that can mean the difference between a character looking awkward or appealing. Drawovers, such as the one shown here, were instrumental in refining those details.

ROYCE WESLEY, SUPERVISING ANIMATOR

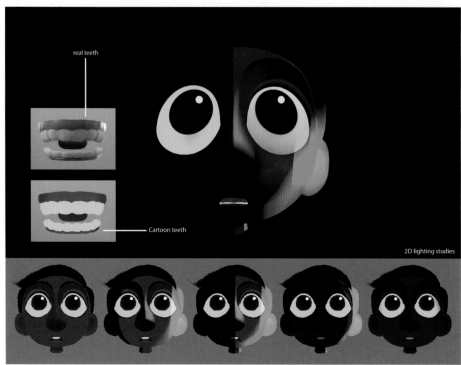

TOP LEFT

Don Crum, Javier Moya, Royce Wesley, and Sanjay Patel, model sheet

LEFT AND OPPOSITE

Chris Sasaki, digital

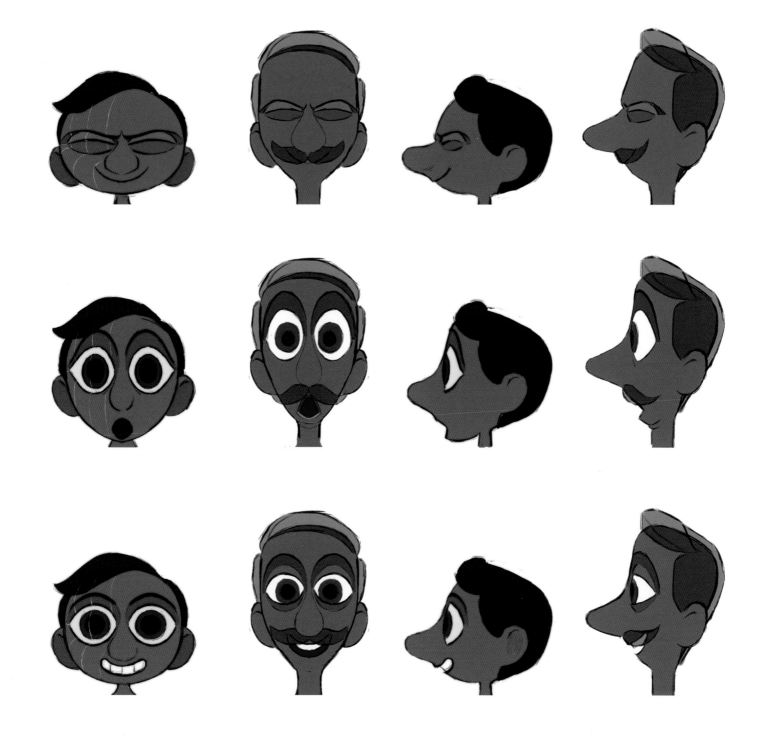

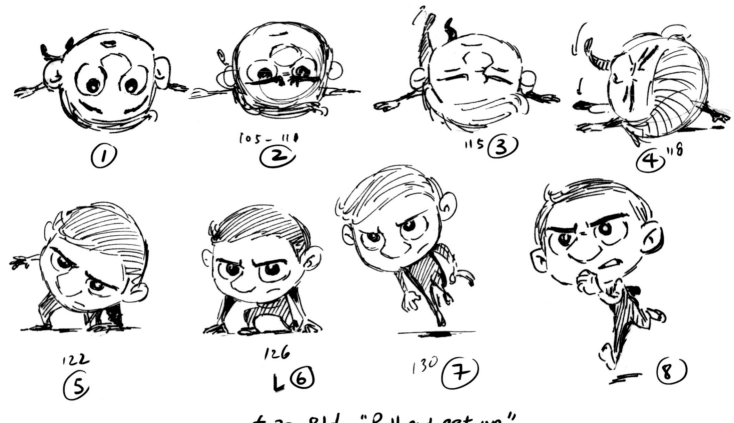

① ②105-111 ③115 ④"18

⑤122 ⑥126 L ⑦130 ⑧

t20-81d "Roll and get up"

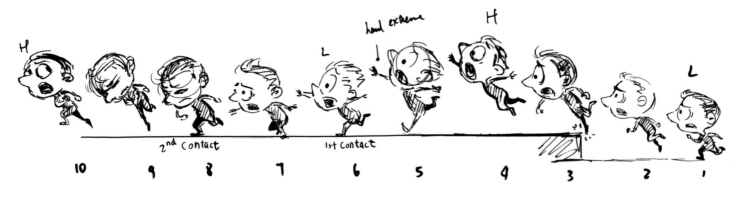

2nd contact — 1st contact — hand extreme — H — L

10 9 8 7 6 5 4 3 2 1

t-14a "stumble"

When playing Little Sanjay, I tapped into my own childhood behaviors. The "Roll, Flip, Crawl" is a way I used to get on my feet, or at least on my knees, when getting up off the floor. Young kids almost never get from one place to another in a simple way. I figured Little Sanjay was no exception. The "Uhh, Dad!" was an exploration of expressing Little Sanjay's attitude through his body language; a melodramatic walk follows his sigh of frustration towards his Dad. Each of these ideas was animated in pre-production to explore Sanjay's attitude and style in movement.

DON CRUM, ANIMATOR

LEFT
Anthony Wong, digital

RIGHT
Don Crum, digital

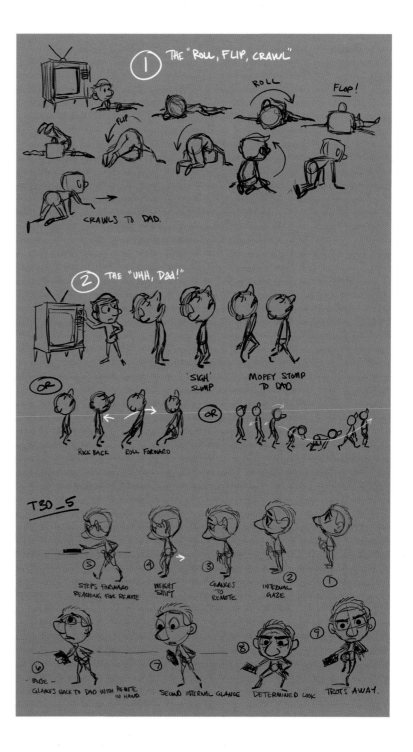

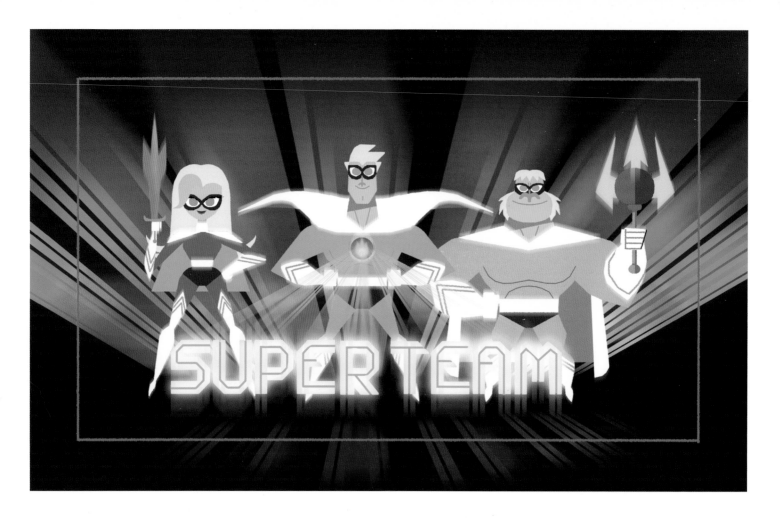

ABOVE AND OPPOSITE
Chris Sasaki, digital

Another fun and challenging aspect of this project was making the 2D animated TV show that Little Sanjay is watching—a short within a short! The visuals of the cartoon needed to contrast sharply with Dad's side of the apartment, while still integrating with the overall look of the film. We wanted a punchy 1970s *Super Friends* sensibility, but with streamlined details for a modern feel and a clear read on screen.

CHRIS SASAKI, PRODUCTION DESIGNER

Craig Foster, digital

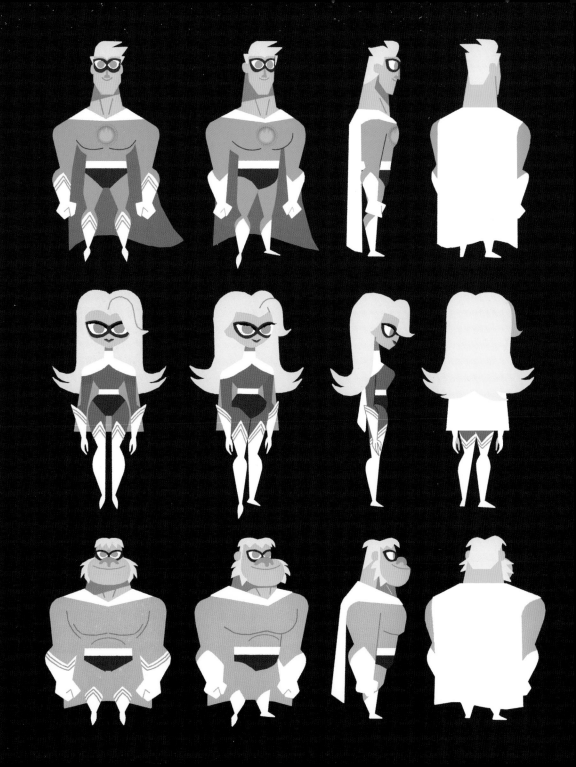

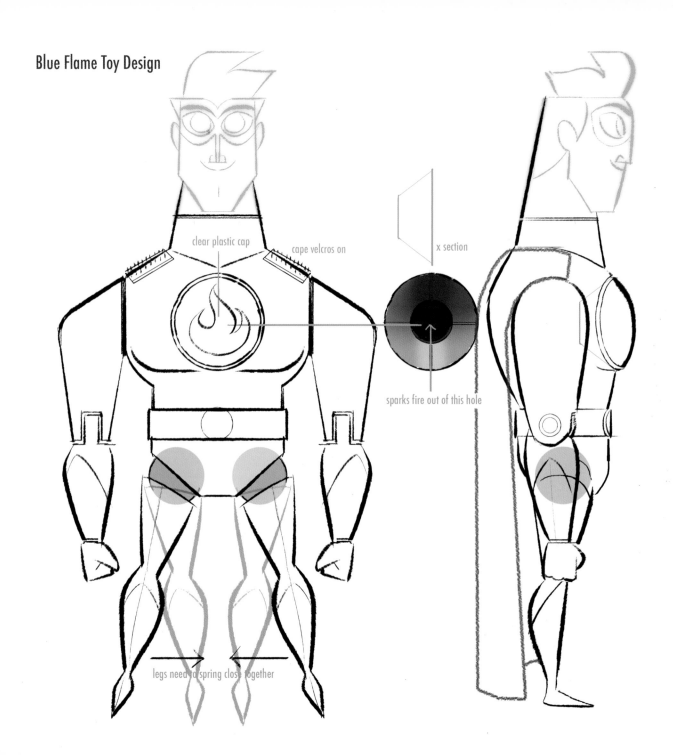

Blue Flame Toy Design

clear plastic cap

cape velcros on

x section

sparks fire out of this hole

legs need a spring close together

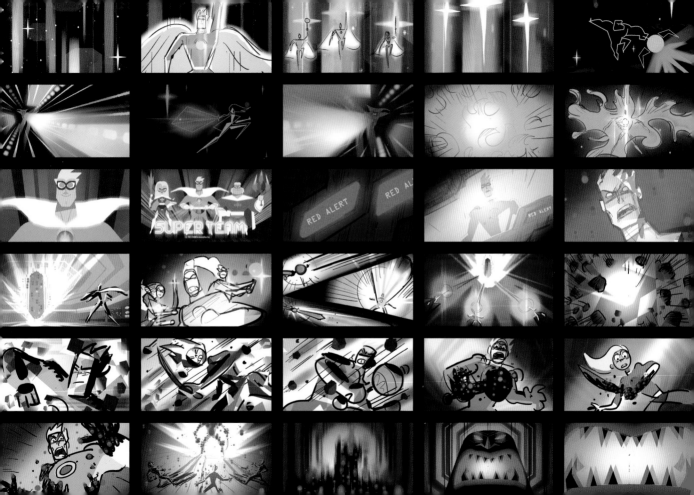

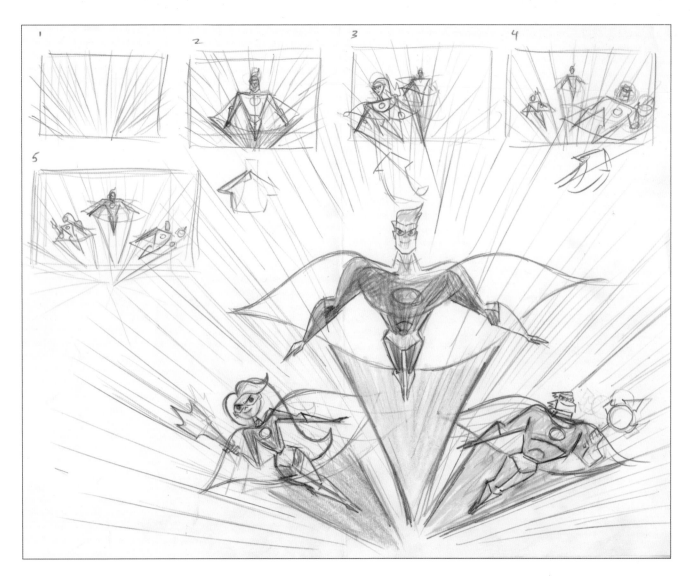

1

2

3

4

5

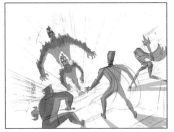 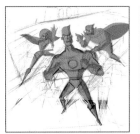 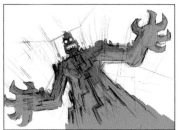 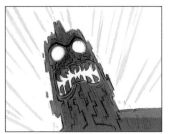

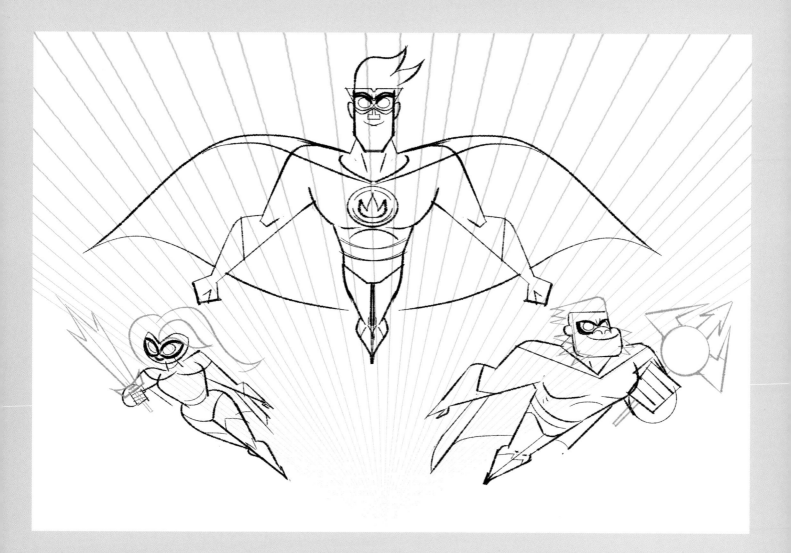

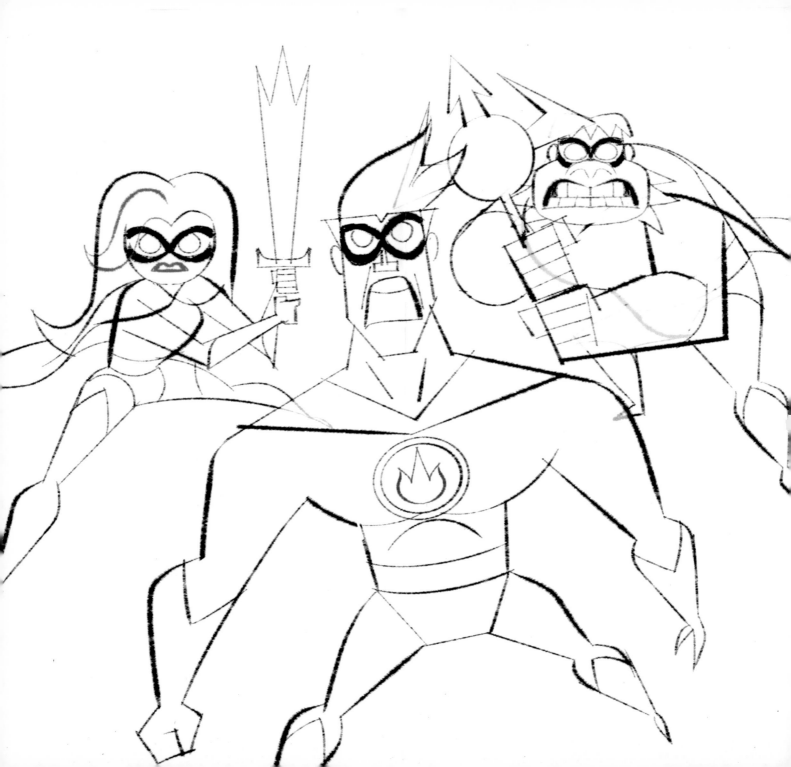

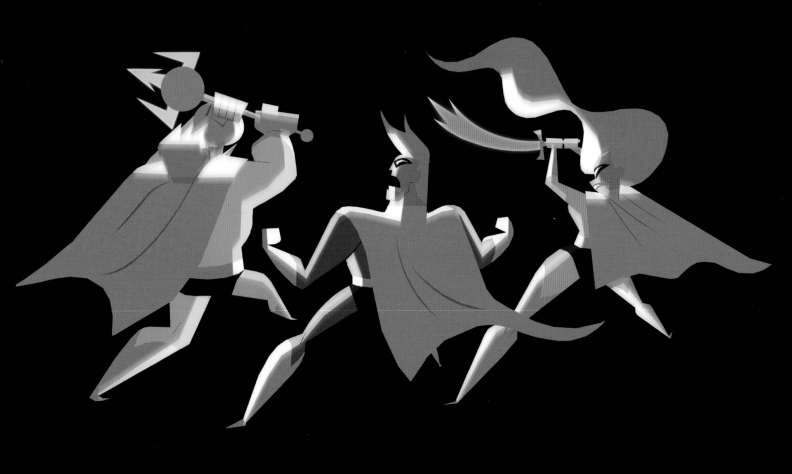

THIS SPREAD
Chris Sasaki, digital

59

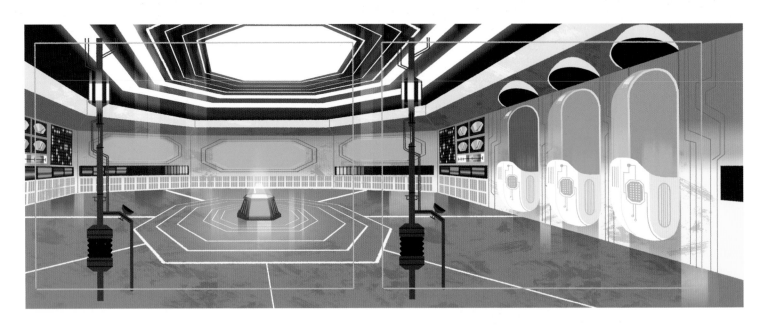

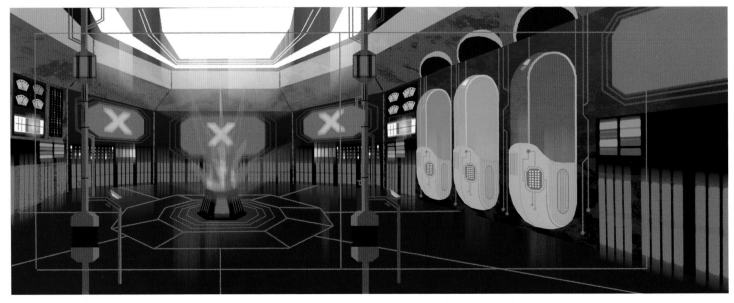

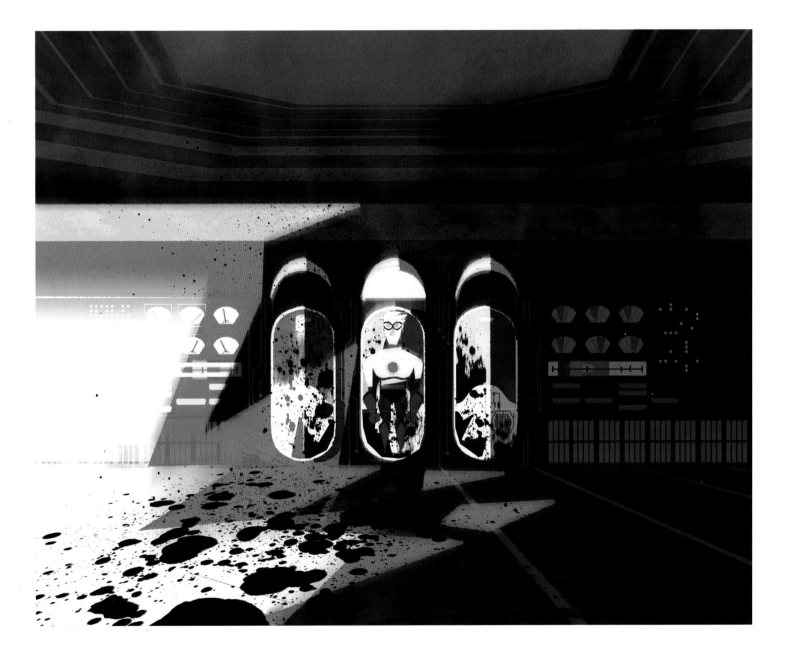

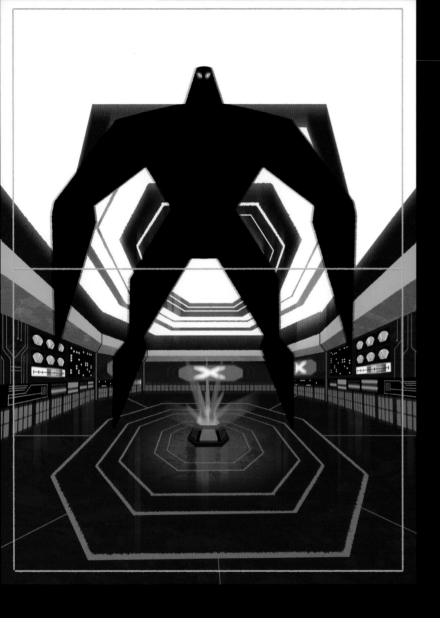

THIS SPREAD
Chris Sasaki, digital

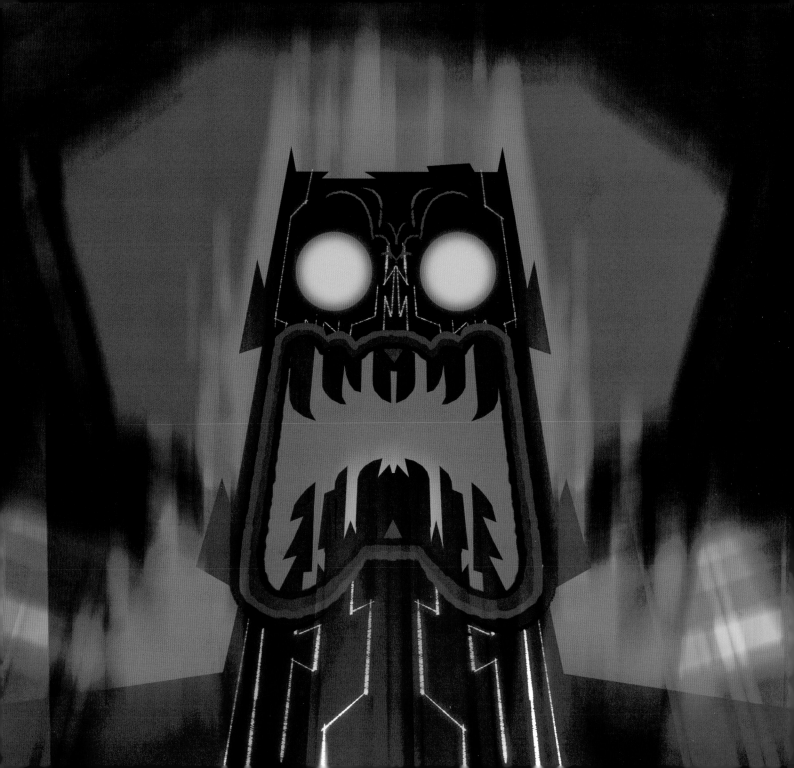

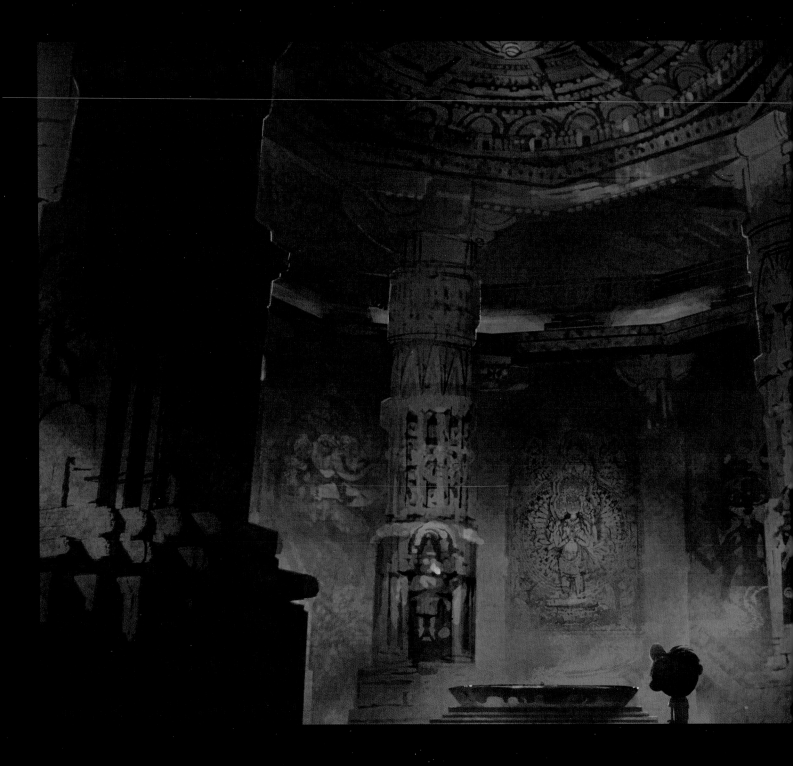

The Temple

DESIGNING ENLIGHTENMENT

Straight away the temple was too awesome. The instant leap from a boring beige-on-beige box to the ornate temple was working against us. Since the arc of our protagonist, broadly speaking, is the journey from irritation to appreciation, we needed to slow things down and pace his awakening. Light is a key element in the story, so we withdrew most of it from the temple when he first enters to make everything feel dead and colorless. Slowly we built color and light back up, until it dramatically transforms the temple into a cosmic three-dimensional comic book. We knew that if our protagonist worships action cartoons then his father's culture needed to come to life in a similar, but more impressive, way. In order to accomplish this we took a departure from the Pixar production norms. We didn't want the cosmic temple or the characters to be photorealistic. We wanted to push the lighting, animation, and dimensions of the world to create something audiences hadn't seen before. I showed an image of neon reflected on a wet window to Production Designer Chris Sasaki. From that one abstract image, he immediately got inside my head and started experimenting. We combined anime-style action and cinematography with stylized lighting and graphic shading. The process of achieving these effects was messy and at times chaotic. But we knew that we had to push every element into the realm of the fantastic to truly earn our audience's appreciation.

Kyle Macnaughton, digital

There are so many layers to Sanjay's story. Once he gave us a peek into his childhood experience with his father's Hindu practice, we tried our best to come up with some visual cues and parallels to support that story and its key emotional beats. For Sanjay's film, a square symbolizes "home" (apartment) and a circle signifies "enlightenment" (temple). When Little Sanjay's father guides him into worship, he enters the temple and is exposed to a foreign realm. In some ways, Little Sanjay starts on the outside, looking in. Within the design process, we tried to exaggerate the disorientation that an unfamiliar experience can cause. The floor plan of the temple was arranged following the structure of a Mandala—a ritual symbol that means "circle" in Sanskrit and represents the universe. Typically, that circle motif fits within the overall form of a square. This particular combination worked well, since this temple served a dual purpose—it is where Little Sanjay confronts his demons and, eventually, where he celebrates the deities; it's where he finds his center.

One of the beauties of animation is the ability to evoke emotion without using verbal exposition all of the time. If done well, a film can be intensely visual, and at the same time, follow the narrative and feel emotionally charged! I think Sanjay's film speaks volumes, with no spoken words.

KYLE MACNAUGHTON, SET DESIGNER

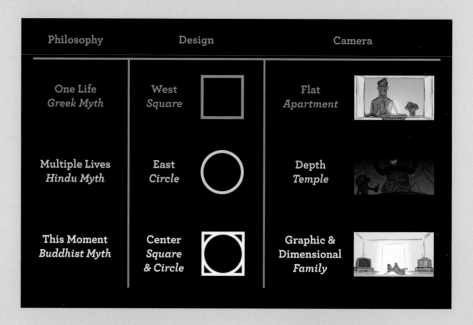

Philosophy	Design	Camera
One Life *Greek Myth*	West *Square*	Flat *Apartment*
Multiple Lives *Hindu Myth*	East *Circle*	Depth *Temple*
This Moment *Buddhist Myth*	Center *Square & Circle*	Graphic & Dimensional *Family*

Diagonal shadows cast and disrupt center

This is how he perceives his culture before versus after his enlightenment

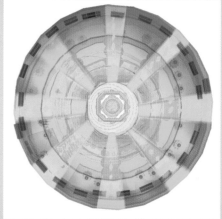

Light radiates from center, sun-like

Glorious, brightly lit, Tron-like intensity, nirvana of the repaired temple

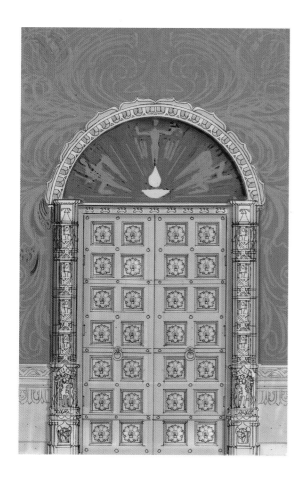

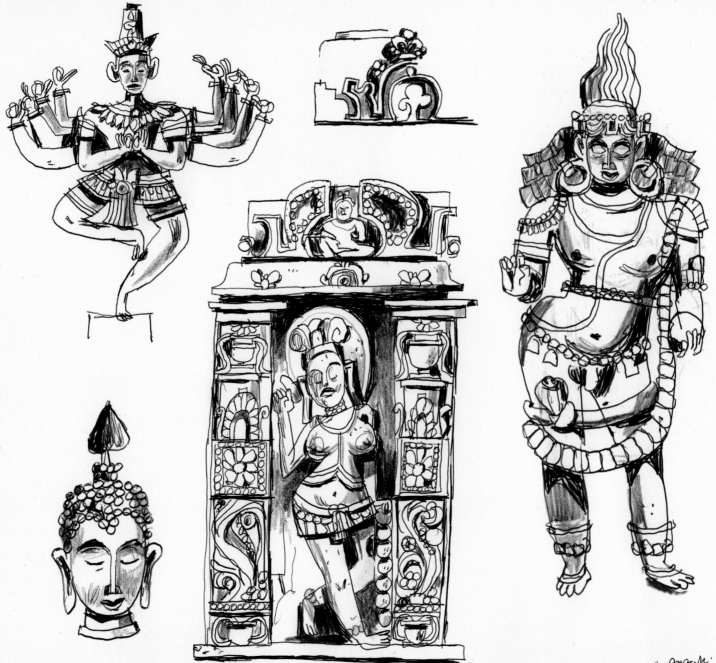

C. Sasaki

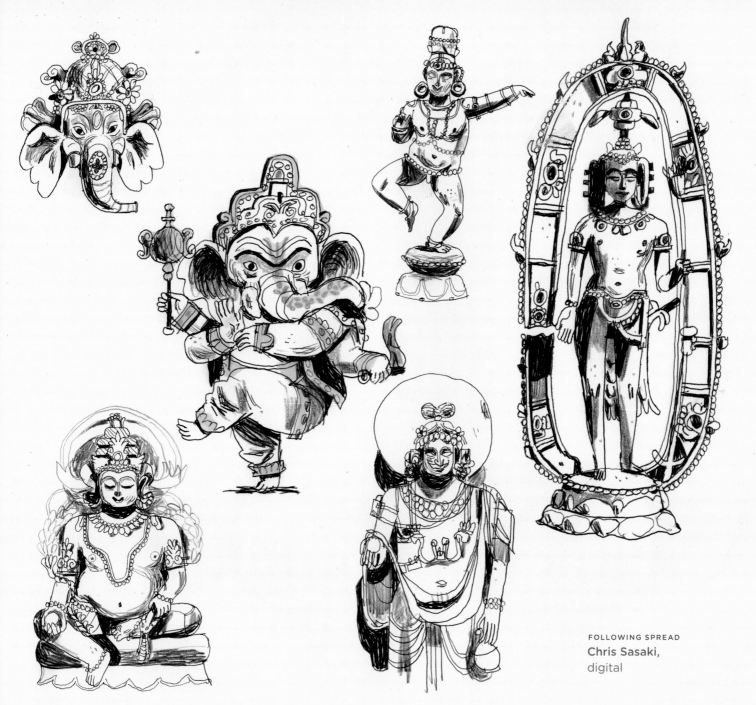

FOLLOWING SPREAD
Chris Sasaki,
digital

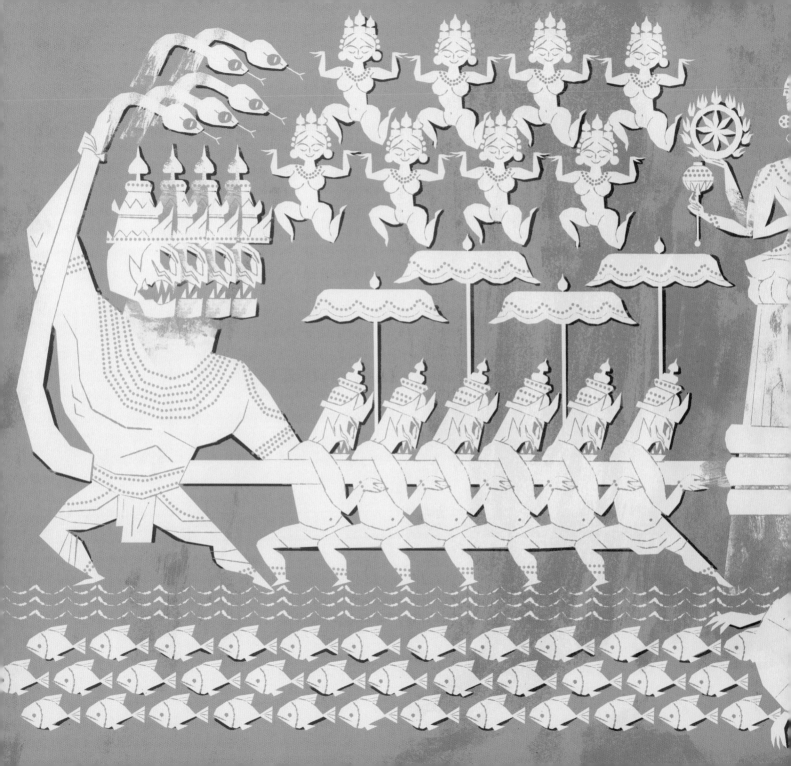

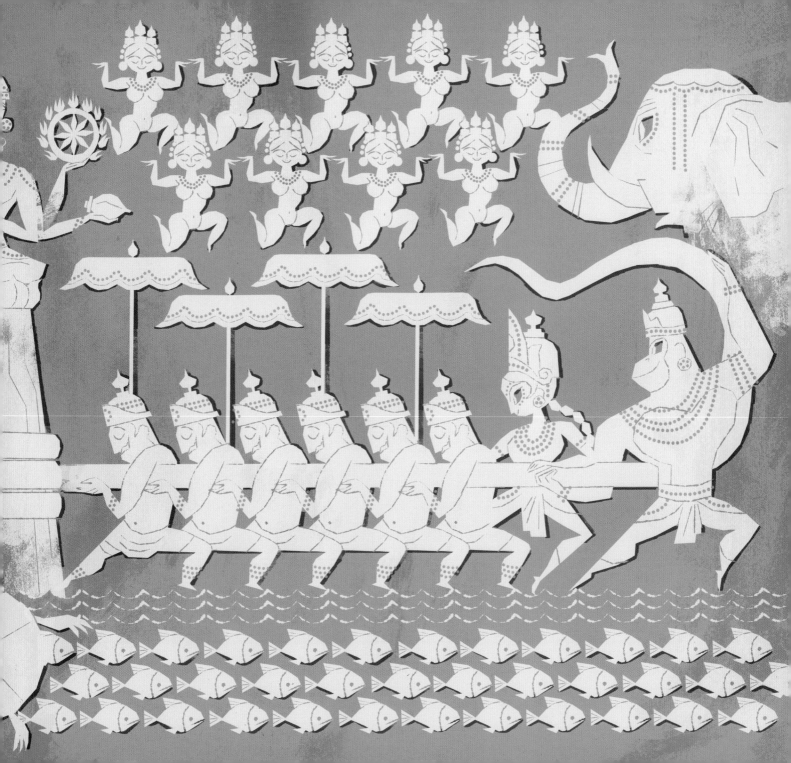

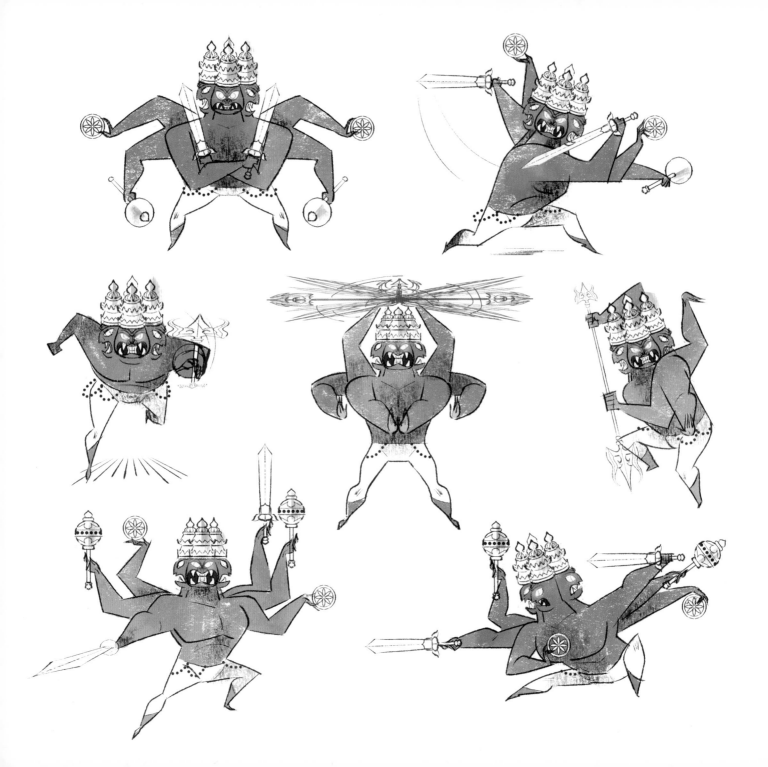

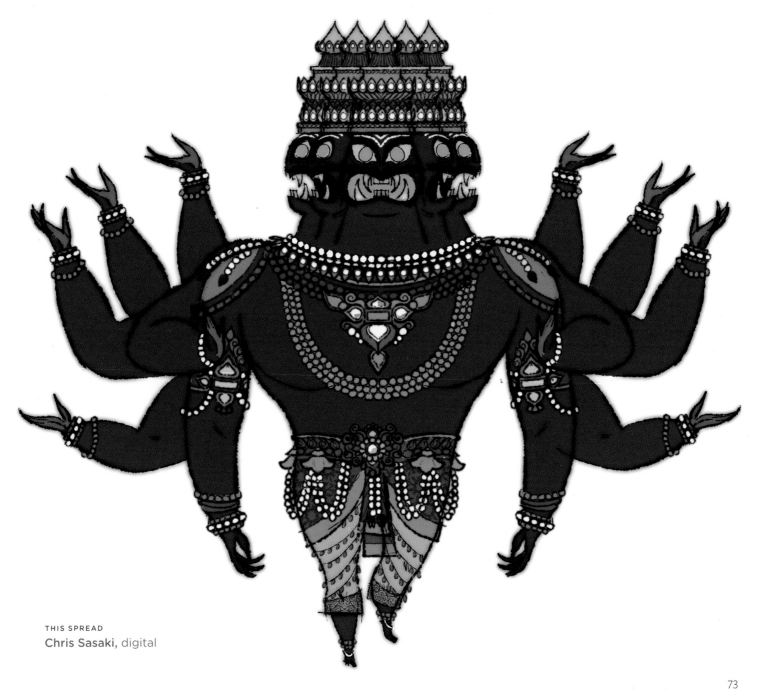

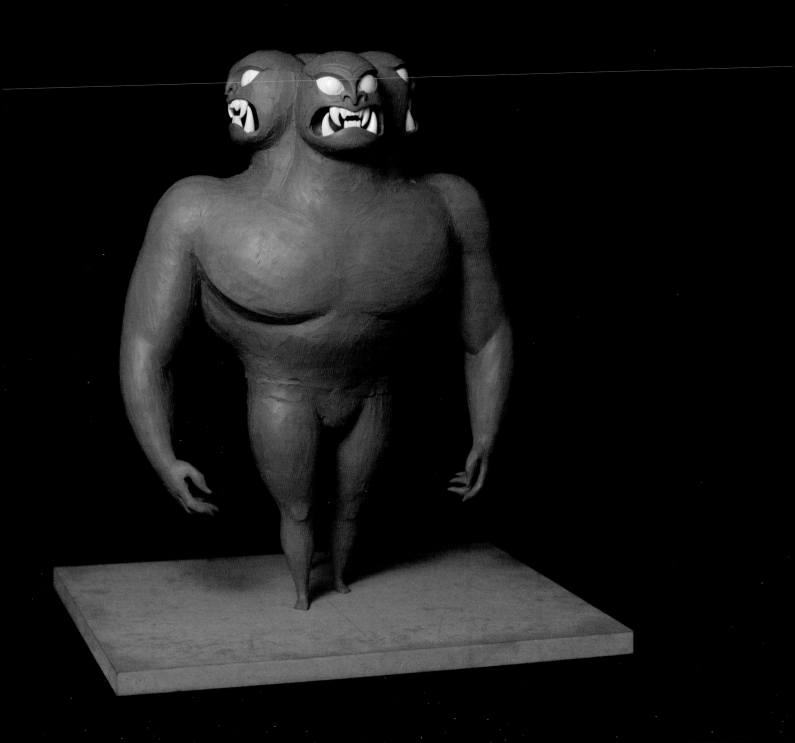

As the demon is the antagonistic deity of the film, we contrasted his design sharply to that of Vishnu. The demon is made of a dark stone material that's cloudy on the inside and rugged on the outside. While his eyes and mouth glow, his pupils are washed out and the silhouette of his large teeth are accentuated, creating a monstrous impression.

SHELLY WAN, SHADING DESIGNER

OPPOSITE
Sculpt by **Greg Dykstra**
Photograph by **Deborah Coleman**

RIGHT
Shelly Wan, digital

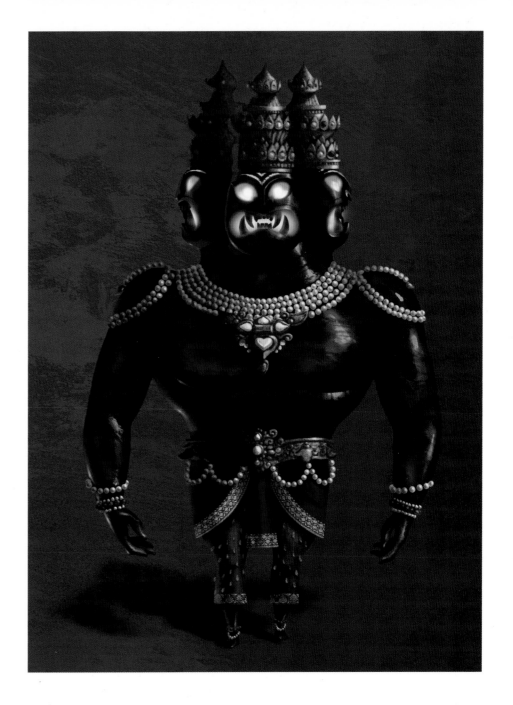

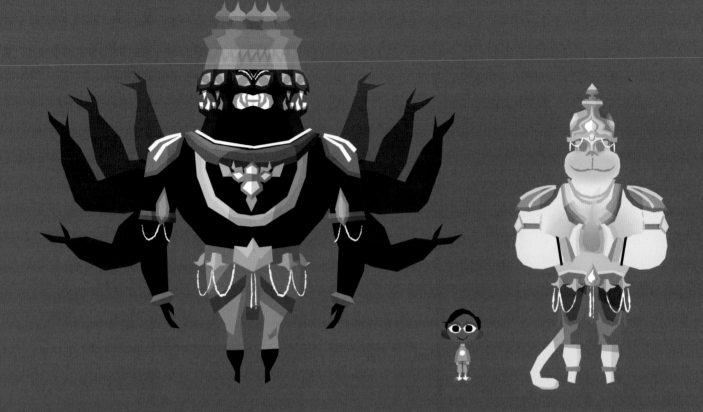

I created a character chart very early on to help visualize the parallels between the superheroes and deities—this version shows a few extra deities and superheroes that ended up getting cut as we edited the story. Sanjay, John Lasseter, and the crew used the chart to discuss ways that color and shape could connect everything together. In the end, we narrowed our approach, using the color blue in the designs of Vishnu, Blue Flame Superhero, and Little Sanjay's pajamas to be the bridge between realities.

CHRIS SASAKI, PRODUCTION DESIGNER

Chris Sasaki, digital

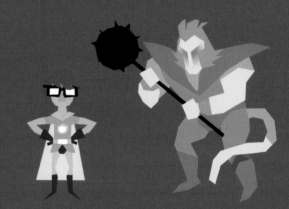

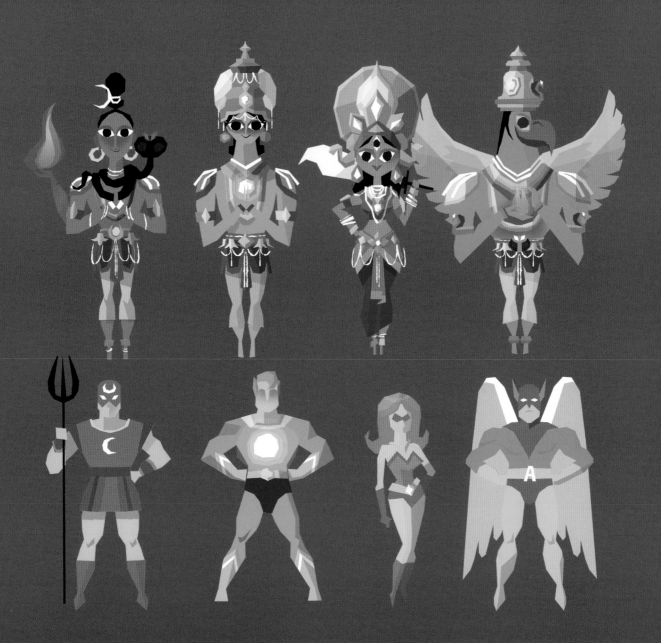

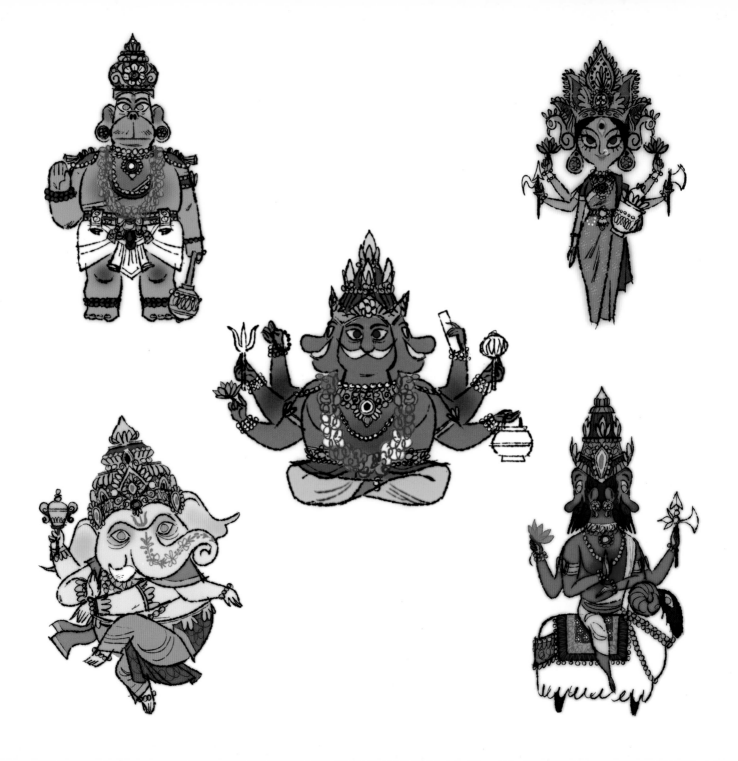

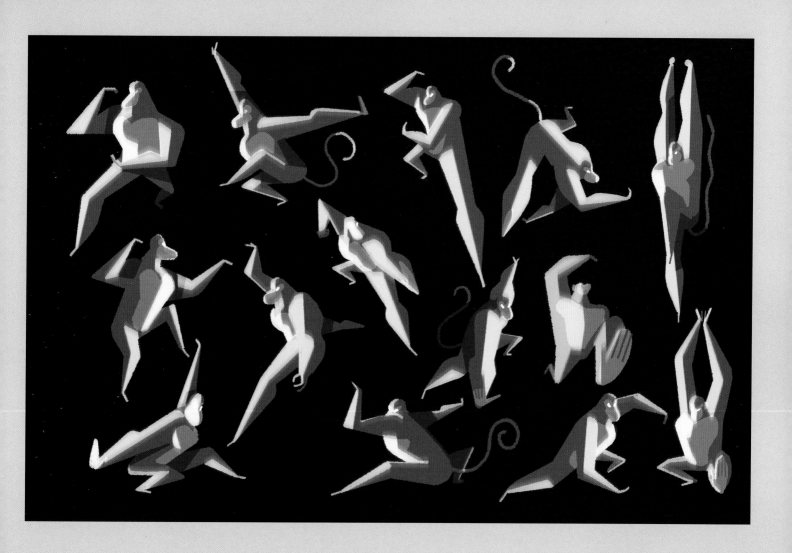

THIS SPREAD
Chris Sasaki, digital

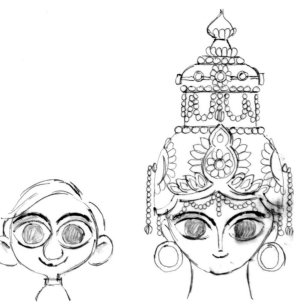

Designing Vishnu was a huge challenge. The character had to embody a lot of contrasting traits. We found historical depictions of the deity to be consistently graceful and androgynous. But we also wanted the character to feel just as strong as Little Sanjay's super-heroes. I remember relating Vishnu's character design to a deer: very graceful in form and movement, but also very powerful. Additionally, we needed to find some common thread to tie all the characters together. In our research of Indian painting and sculpture, we found very elegant, graphic, almond-shaped eye motifs, which we decided to emphasize in all of our characters and carry throughout the film.

CHRIS SASAKI, PRODUCTION DESIGNER

THIS PAGE
Chris Sasaki, pen and colored pencil

OPPOSITE
Chris Sasaki, digital

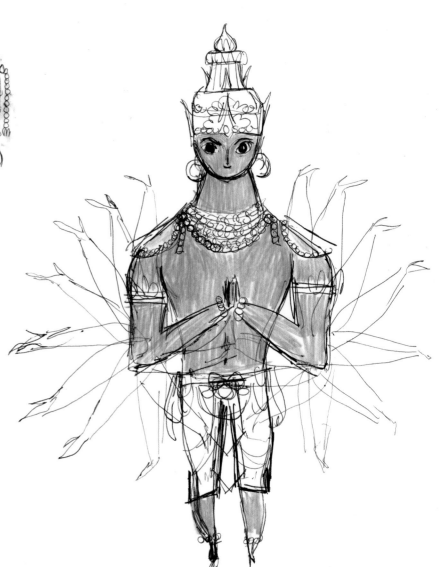

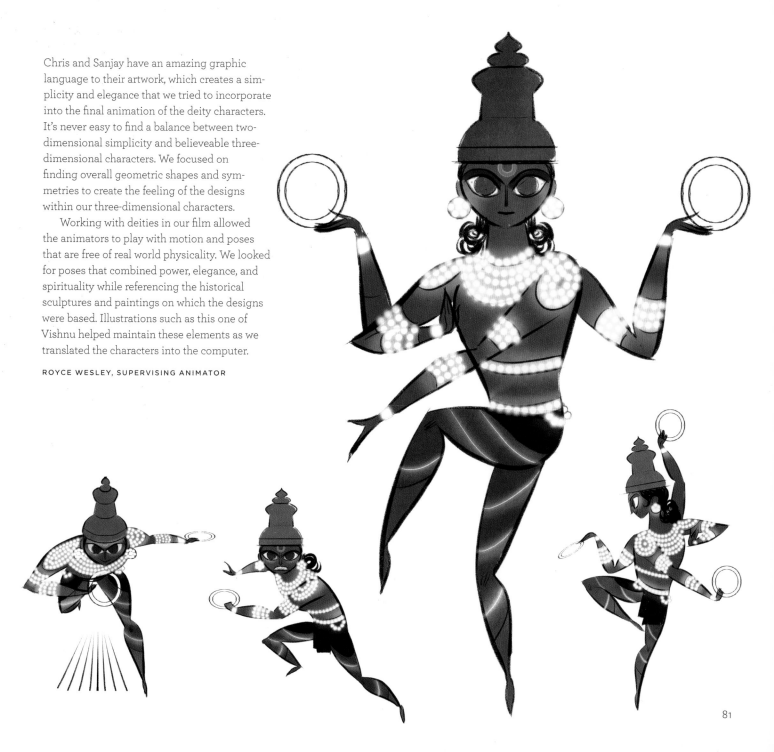

Chris and Sanjay have an amazing graphic language to their artwork, which creates a simplicity and elegance that we tried to incorporate into the final animation of the deity characters. It's never easy to find a balance between two-dimensional simplicity and believeable three-dimensional characters. We focused on finding overall geometric shapes and symmetries to create the feeling of the designs within our three-dimensional characters.

Working with deities in our film allowed the animators to play with motion and poses that are free of real world physicality. We looked for poses that combined power, elegance, and spirituality while referencing the historical sculptures and paintings on which the designs were based. Illustrations such as this one of Vishnu helped maintain these elements as we translated the characters into the computer.

ROYCE WESLEY, SUPERVISING ANIMATOR

81

We knew we wanted a lot of strong poses for the deities, like one would see in action cartoons, but it needed to be within an Eastern context. We researched a lot of Indian dance movement and Kalaripayattu martial arts. These styles themselves reference a lot of animal gestures. We also wanted to make sure we preserved the iconic depiction of multiple arms that is prevalent in Indian art. Our animation team provided great solutions that allowed characters to leave motion trails while in action, demonstrating the deities' ability to perform hundreds of acts at the same time.

CHRIS SASAKI, PRODUCTION DESIGNER

Chris Sasaki, digital

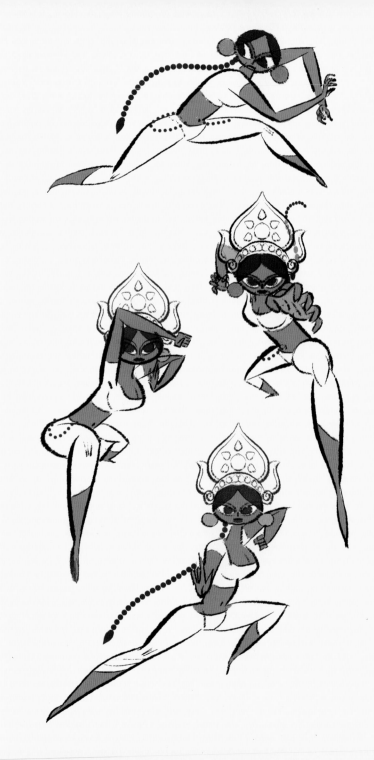

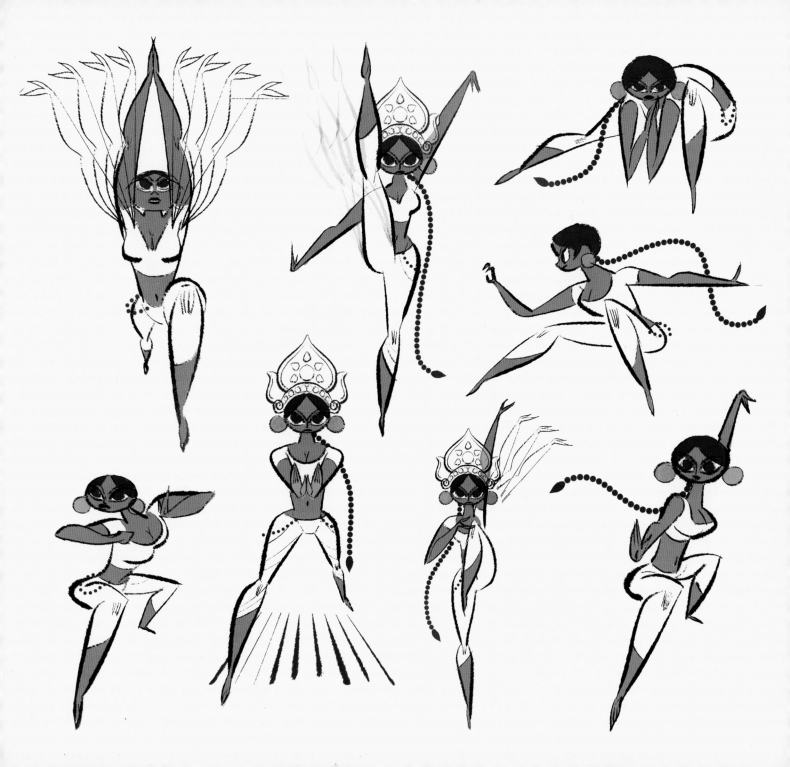

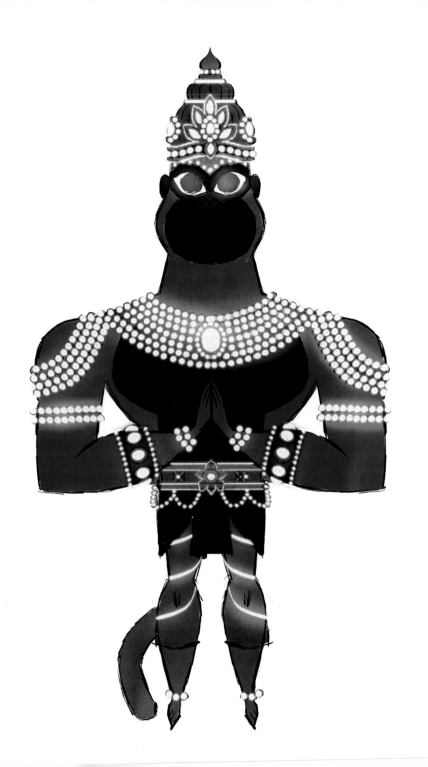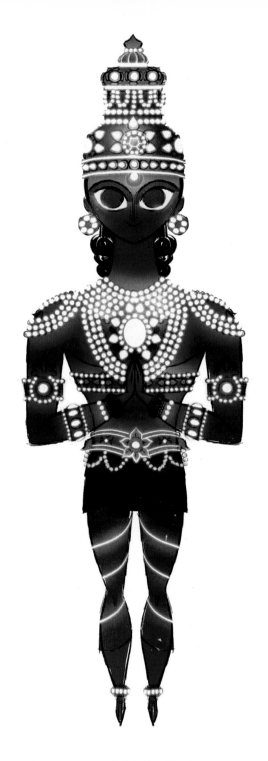

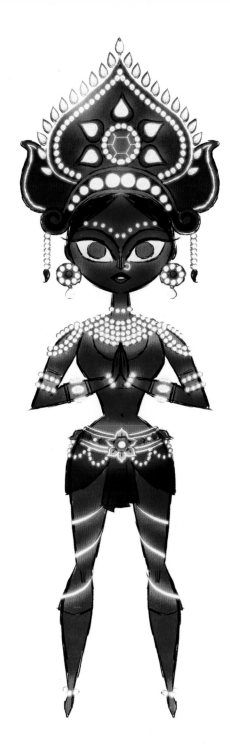

At one point we had five deities in the story (page 75). I never intended to feature so many deities. Initially, I wanted the boy to meet only one deity—Vishnu. Since the story centered on a father trying to preserve his culture, Vishnu seemed like the ideal choice given his role in Hindu mythology as the god of preservation and balance. But as the story developed, we realized we needed a team to parallel the kid's experience with Western pop culture, and so we explored a few more from the Hindu canon. Much has been written about the power of the goddess Durga. When all the gods were bested by a troublesome demon they combined their powers and she is the result, the goddess of power and protection. I also couldn't miss the chance to introduce one of the most beloved demi-gods of Hinduism—the monkey god Hanuman. He is no ordinary monkey, as he is the son of the wind god and has fantastic powers. The least of which is to make any child fall in love with his nimbleness.

SANJAY PATEL, WRITER AND DIRECTOR

THIS SPREAD
Chris Sasaki, digital

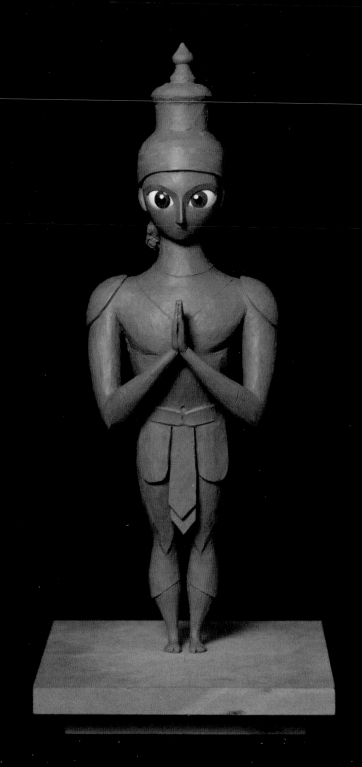

OPPOSITE
Sculpt by **Greg Dykstra**
Photograph by **Deborah Coleman**

RIGHT
Shelly Wan, digital

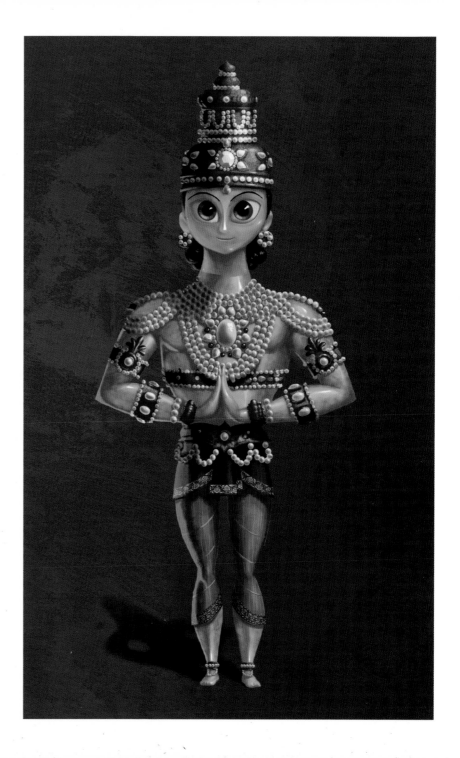

The design of Vishnu, like all of the gods in
Sanjay's Super Team, needed this elegance
of symmetry. Their forms and lines moved
gracefully from majestic to fine. Ancient
and stunningly powerful beings with giant
childlike eyes and colossal heroic bodies
on dainty feet: they were all built on these
beautiful contrasts.

GREG DYKSTRA, SCULPT DESIGNER

As Vishnu is one of the supreme deities of
Hinduism and the main hero in the trio, we
designed him as elegant and dignified, akin
to a precious gemstone. In this concept
painting, I tried to capture the brilliant
translucency and reflective quality of pol-
ished jade in Vishnu's skin.

SHELLY WAN, SHADING DESIGNER

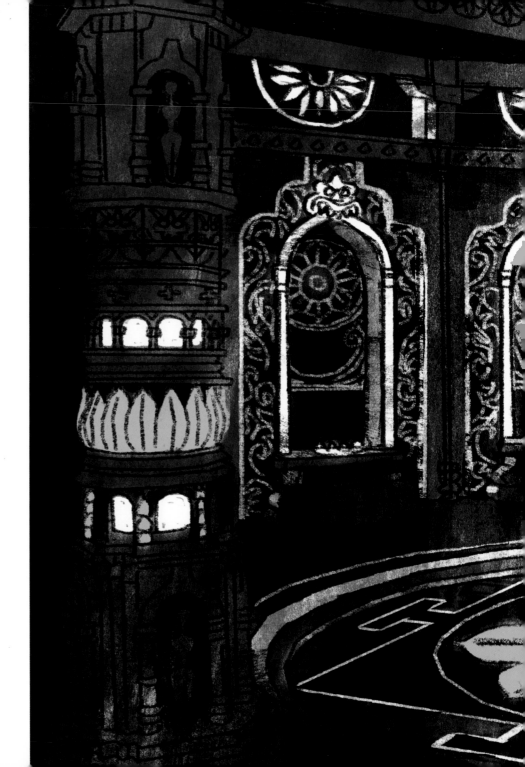

THIS AND FOLLOWING SPREAD
Chris Sasaki, digital

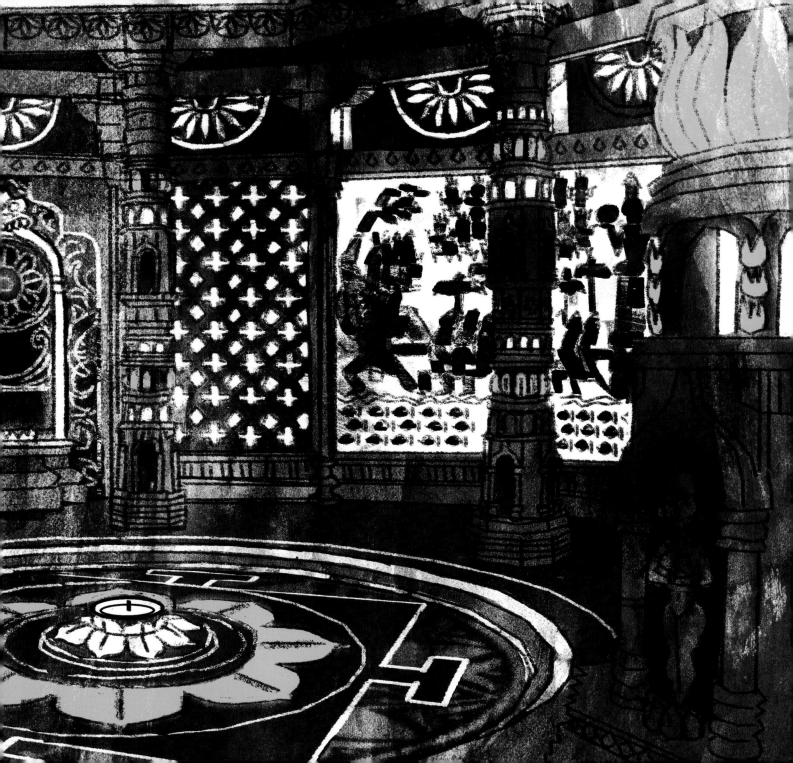

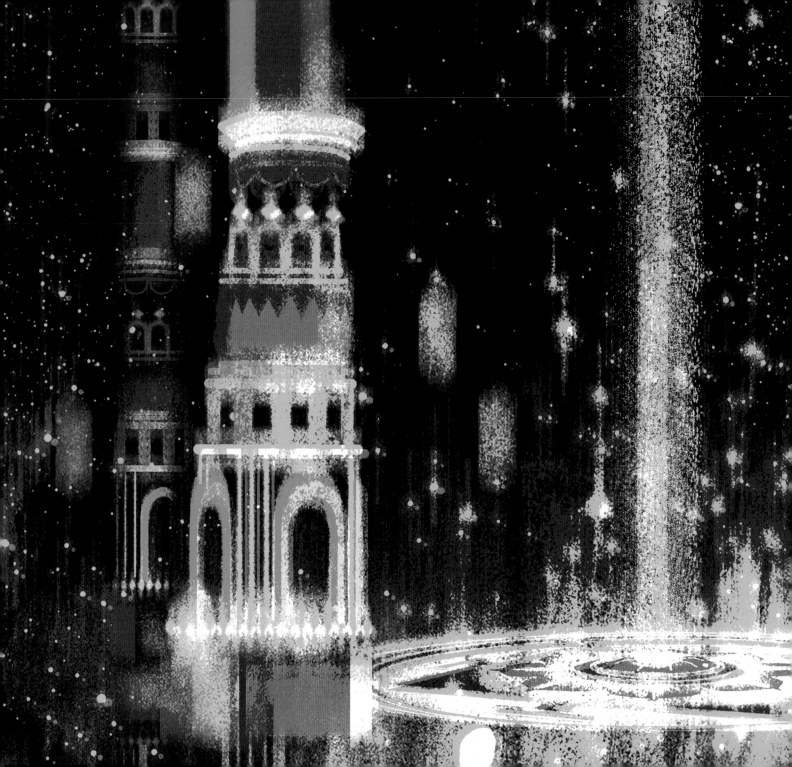

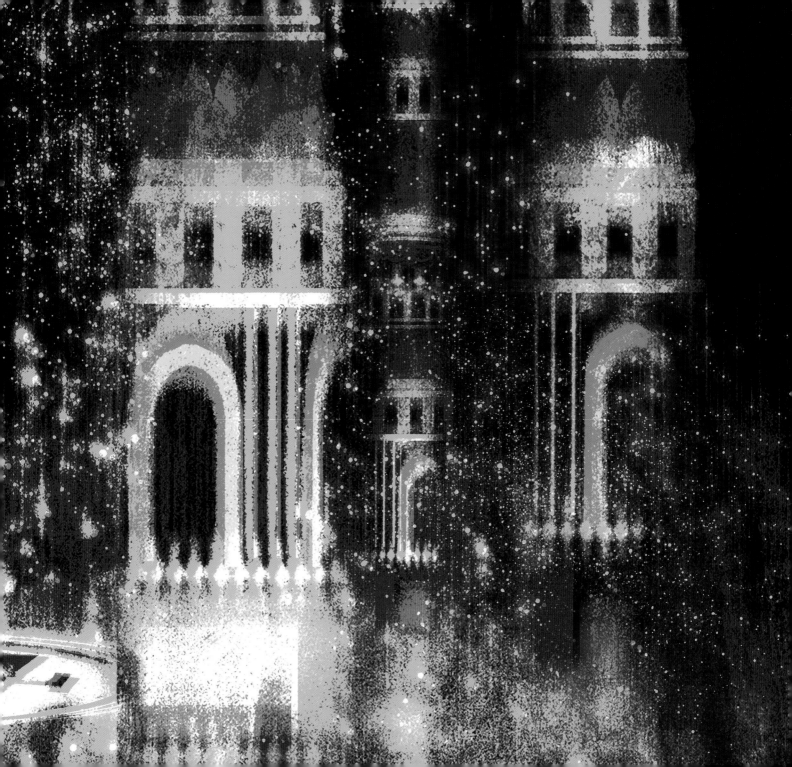

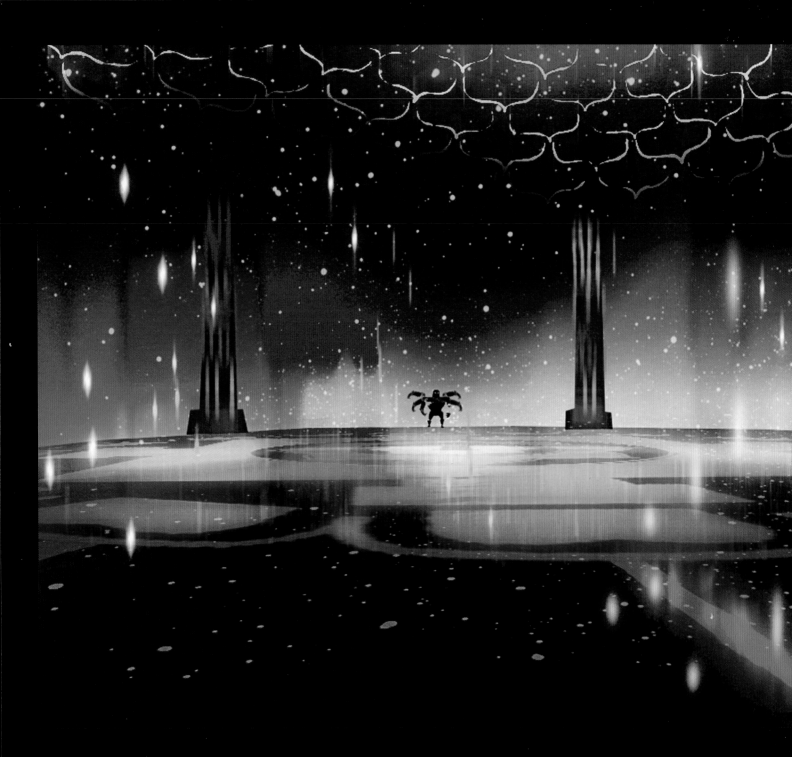

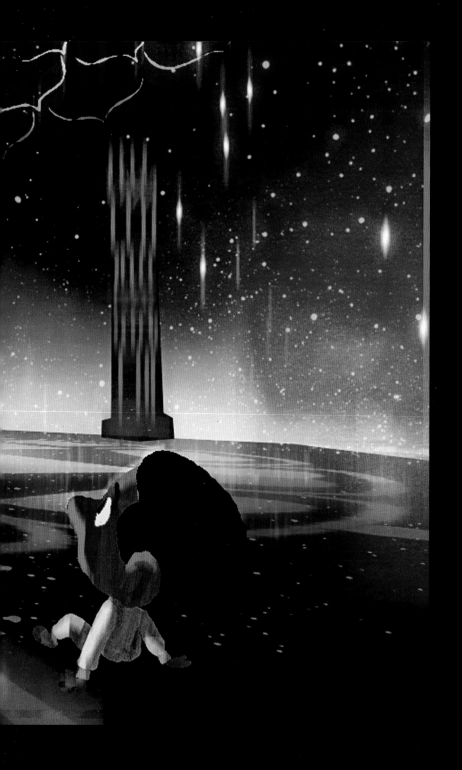

In this scene, Little Sanjay is transported from the physical to the cosmic realm. When the diya flame is lit, the walls zoom away and the temple grows five times larger to give room for the coming battle. Solid stone is replaced by multi-colored moving auroras and living particles of light that flow along the veins of the structure, revealing a background of stars beyond the walls. Bringing this transformation to the screen required the ingenious ideas of layout artists, set shading artists, visual effects artists, and lighting artists working side by side. They combined clever camera work, a huge number of architectural patterns, aurora and particle effects, and stylized lighting techniques in a complex composite to produce the final images.

DARWYN PEACHEY,
SUPERVISING TECHNICAL DIRECTOR

THIS SPREAD
Chris Sasaki, digital

FOLLOWING THREE SPREADS
Paul Abadilla, digital

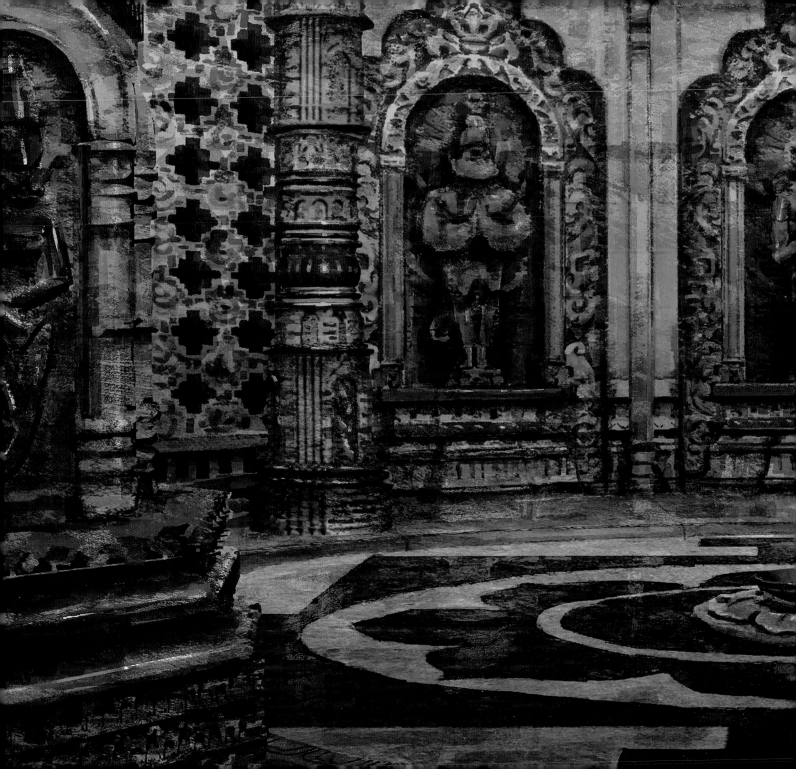

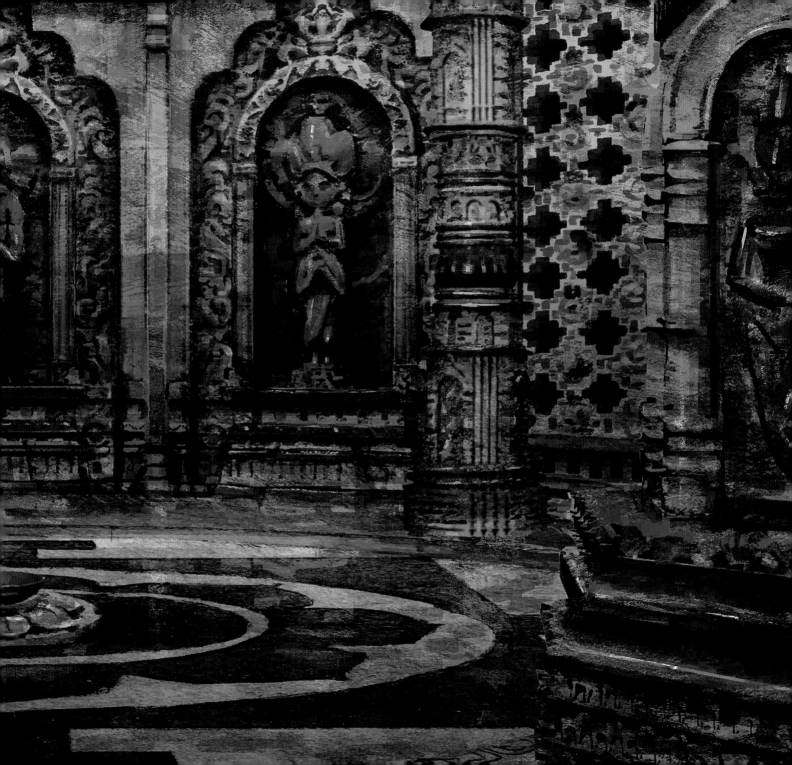

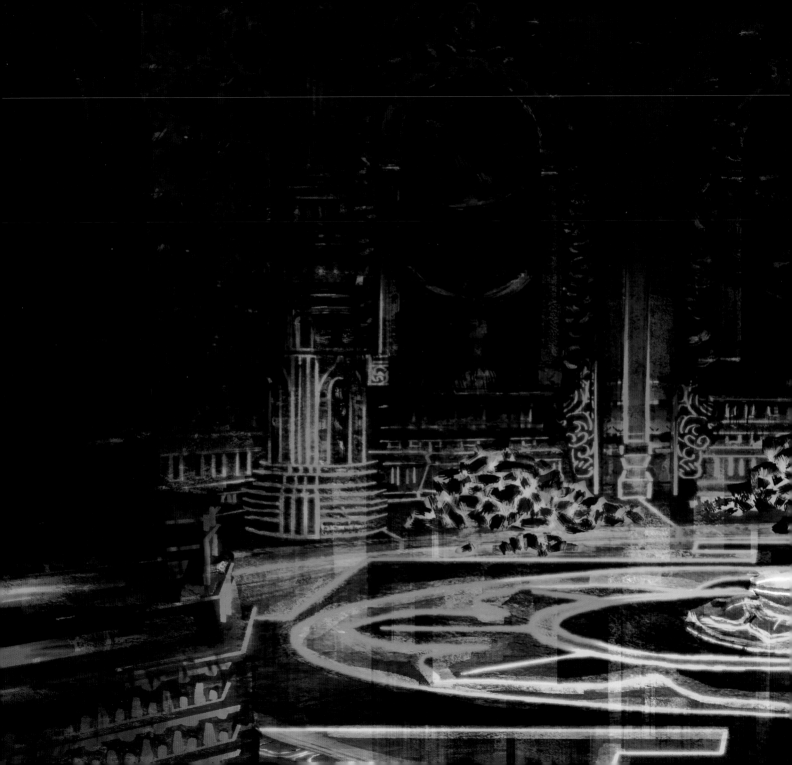

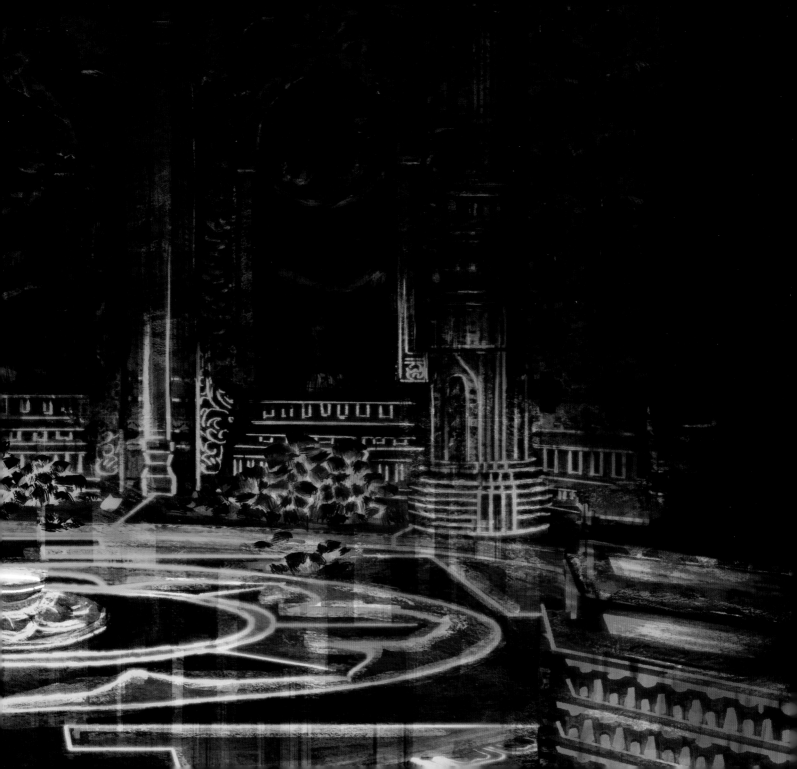

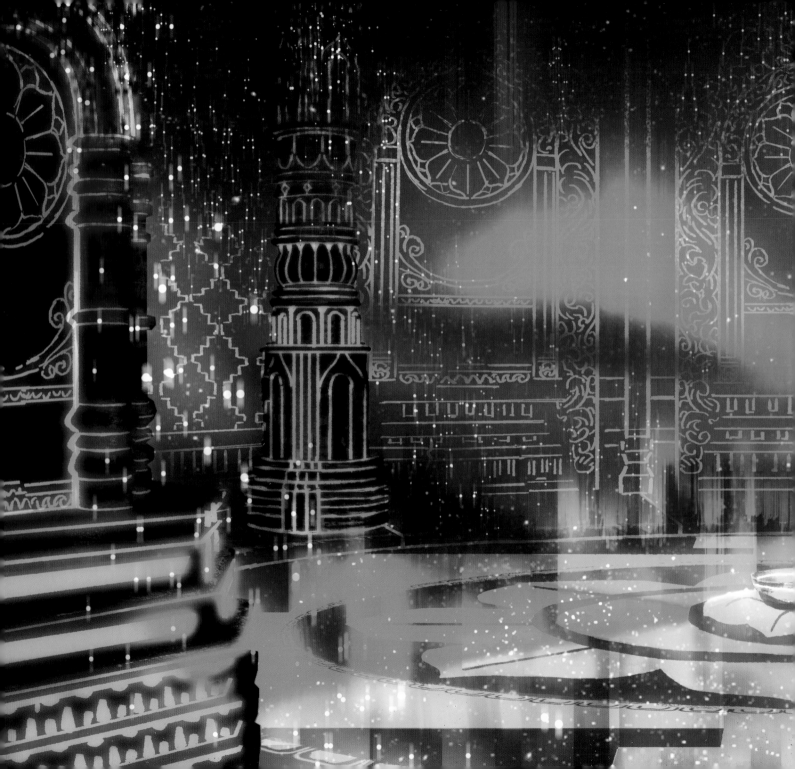

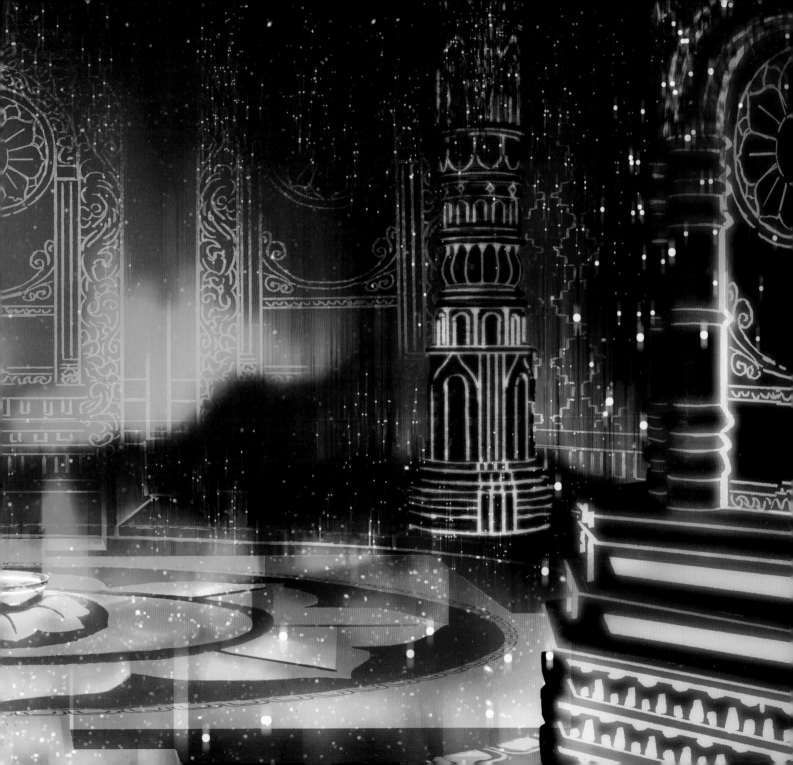

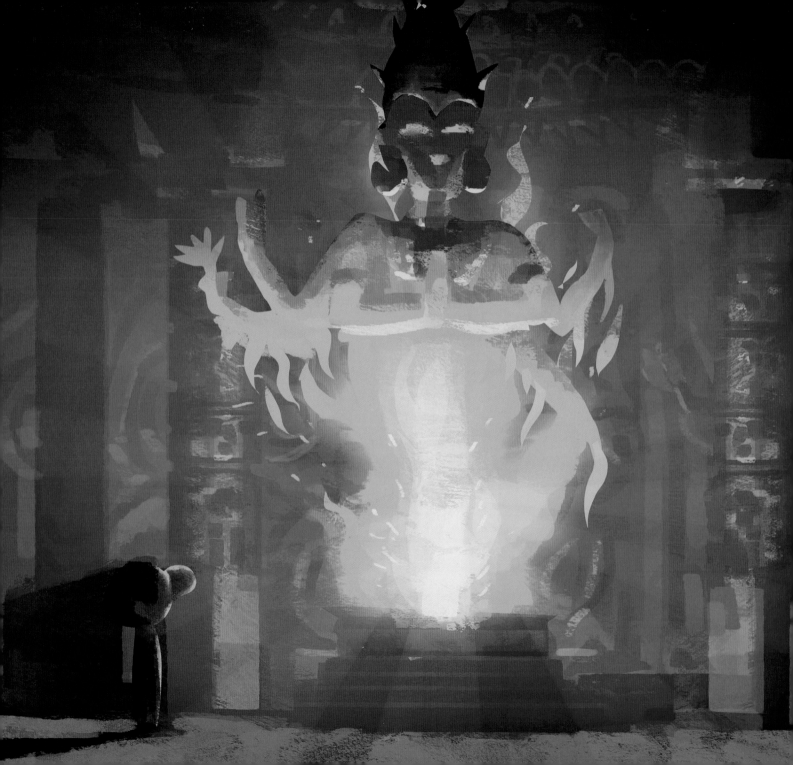

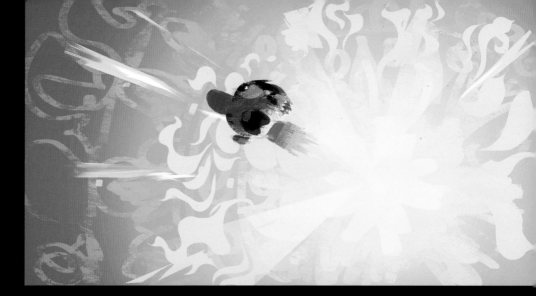

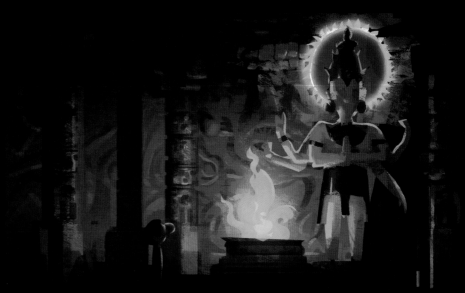

THIS SPREAD
Robert Kondo, digital

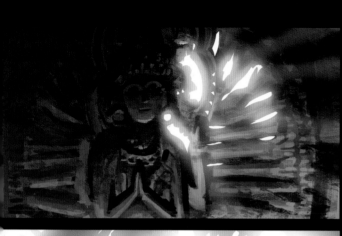

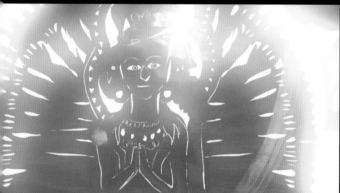

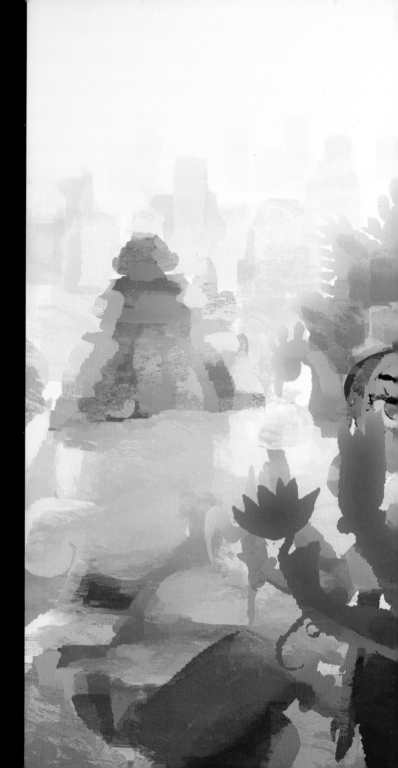

THIS SPREAD
Robert Kondo, digital

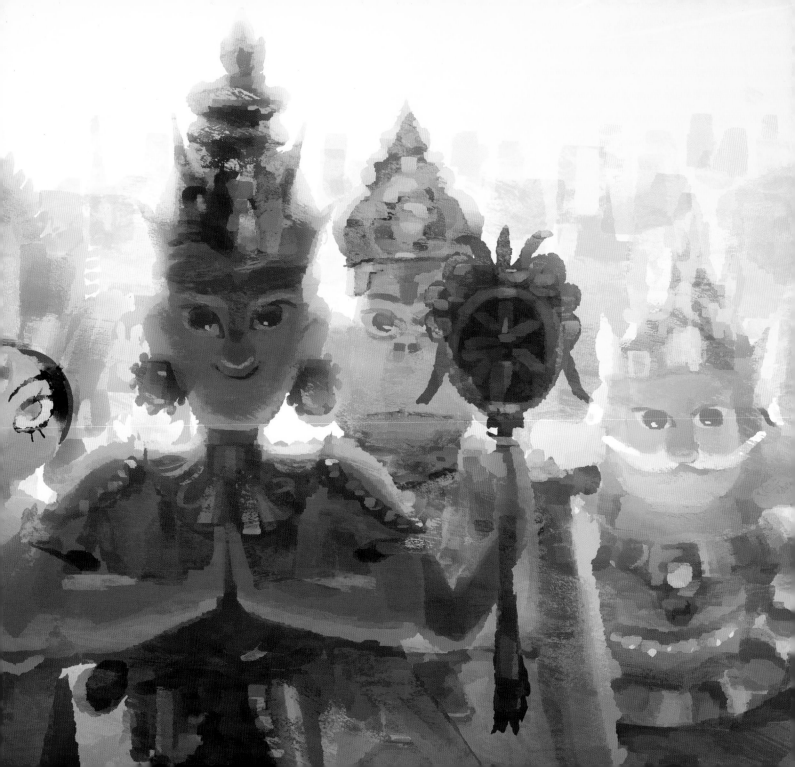

The deities are unique and dazzling characters that arise in a glowing, swirling, and levitating moment of pure magic. In creating them, we had to think outside the box of the regular Pixar production pipeline. Lighting and Shading collaborated to develop a hybrid 2D/3D approach to create their distinctive look. We implemented a cartoon style effect for the graphic look, along with softer shaping from light-emitting effects elements. This was combined with a heavy use of compositing techniques, and made for a layered approach that was a departure from our normal in-camera working style at Pixar. The end result is stunning, resplendent characters–the true superheroes!

CHARU CLARK, LIGHTING SUPERVISOR

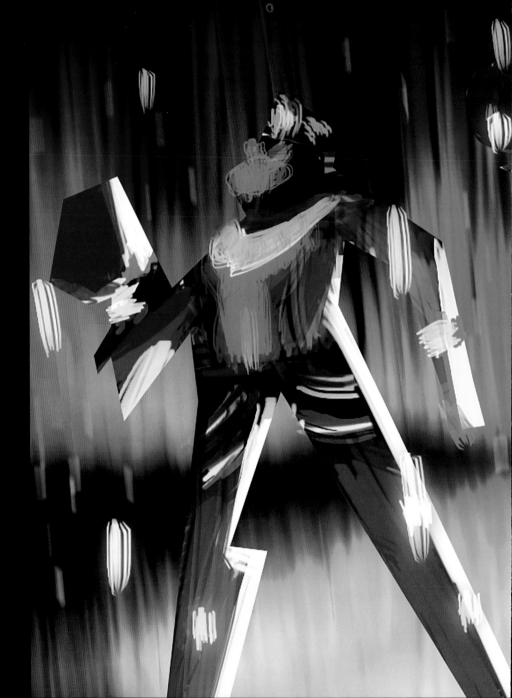

Paul Abadilla, digital

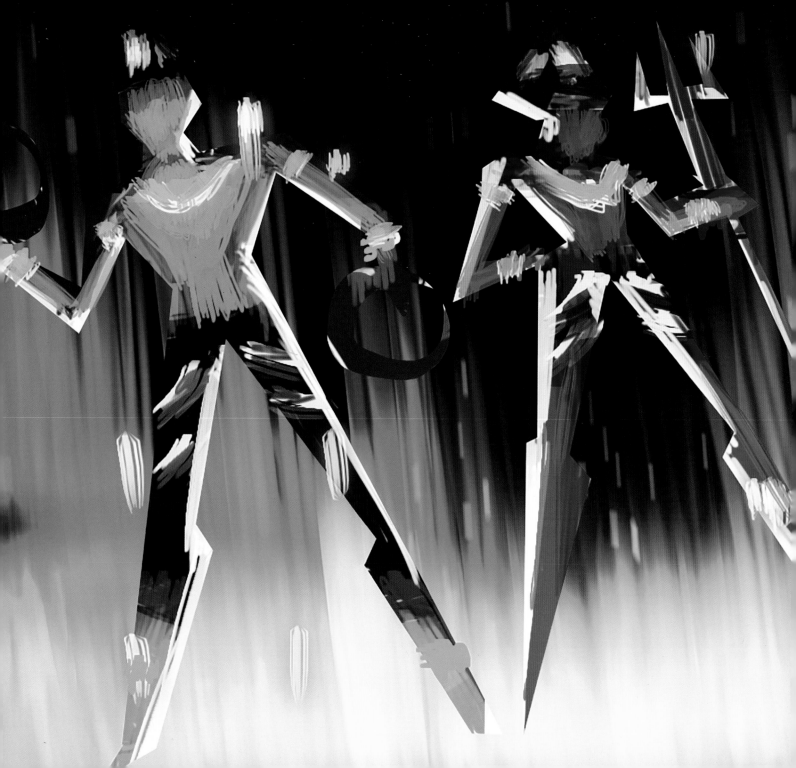

As Little Sanjay lights the diya, we wanted to transport the audience from a dark and dead temple to a place worthy of the magnificent deities. And so the temple transforms into a mesmerizing, cosmic, and living space that is pulsing with energy and infused with light. This provided a great stage for the fantastic action-filled sequence that followed. For the first part of the sequence we maintained a limited color palette, where the temple was created with golden pinpricks of light that flowed and pulsed, with colored auroras behind the deities. Limiting the color really helped clarify the action. It was also a great complement to the latter part of the story when Little Sanjay rings the diya with his toy and color floods into the temple.

CHARU CLARK, LIGHTING SUPERVISOR

Once the flame is reignited, the temple suddenly transforms around us into a cosmic reflection of itself. Visual reference points and the laws of physics fall away, leaving the viewer in a space that distorts and shifts around them. The storyline and the actions of the characters drive the shifting nature and the evolution of this space. Drawing inspiration from traditional anime and the graphic nature of Sanjay and Chris's artwork, the crew worked to create a visual experience that would captivate the viewers and keep them on the edge of their seats, wondering what would or could happen next.

BILL WATRAL, VISUAL EFFECTS SUPERVISOR

TOP
Chris Sasaki (digital paintover), and Charu Clark and Aaron Dittz (lighting), digital

MIDDLE AND BOTTOM
Chris Sasaki (digital paintover), and Keith Cormier and Aaron Dittz (lighting), digital

OPPOSITE
Paul Abadilla (digital paintover), Keith Cormier and Airton Dittz (lighting), digital

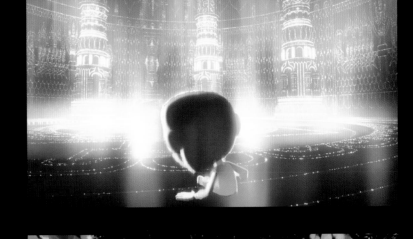

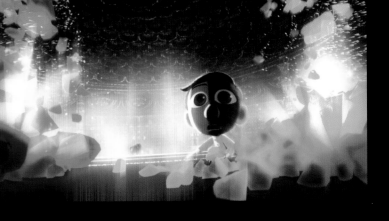

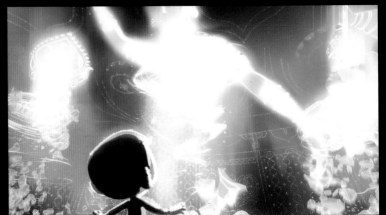

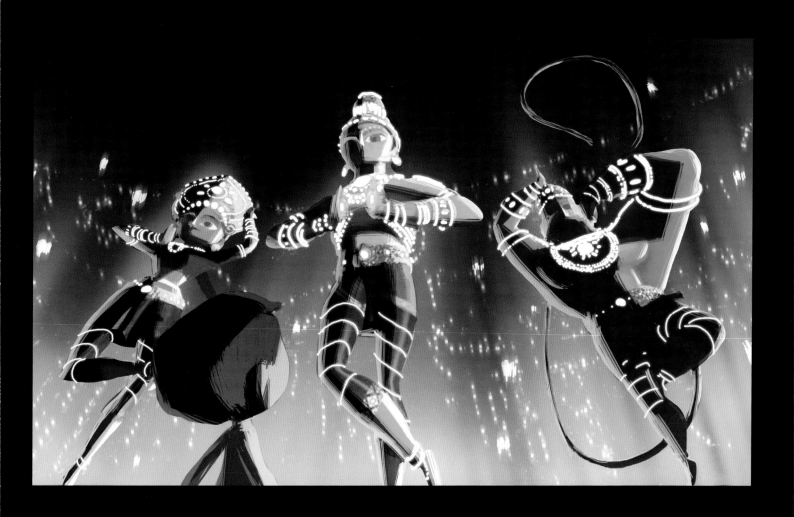

This piece was done when we were deep in production. Everyone was wearing down, especially me. I was feeling really anxious about the film. One night I just couldn't sleep. There weren't enough hours in the day for my brain to process all the things that it needed to. So at three A.M., without my contact lenses, I opened up Photoshop (a program that I rarely use) and started to work on the problem that had been keeping me up. Having just seen the then-new animated *TRON: Uprising* series I had been totally blown away with how the film-makers lit and shaded CG to look graphic and unique. Up until this point I had stayed out of the art development for the film. I had tackled the deities artistically for so long before making the short that I wanted Chris Sasaki to bring a fresh take to them. Still, there was an itch here that needed to be scratched, so I stayed up and tried to channel the look I wanted to see on the screen into this piece. A few days later I brought it to the team and it definitely shook things up. In the end I decided that we didn't need to be this graphic. Hints of it were all we needed to make a connection to the boy's graphic 2D cartoon.

SANJAY PATEL, WRITER AND DIRECTOR

Sanjay Patel, digital

FOLLOWING SPREAD
Paul Abadilla, digital

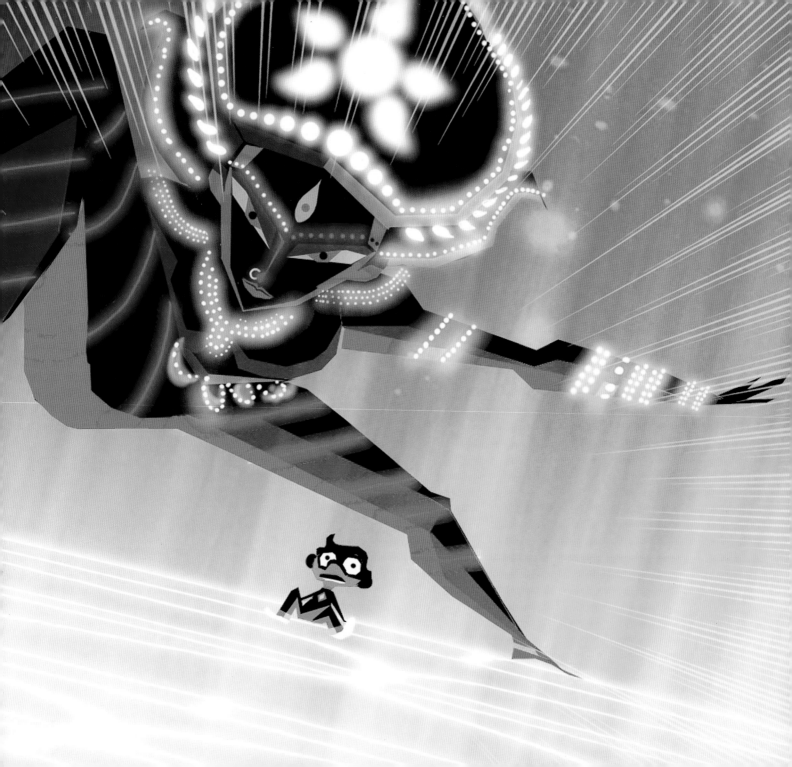

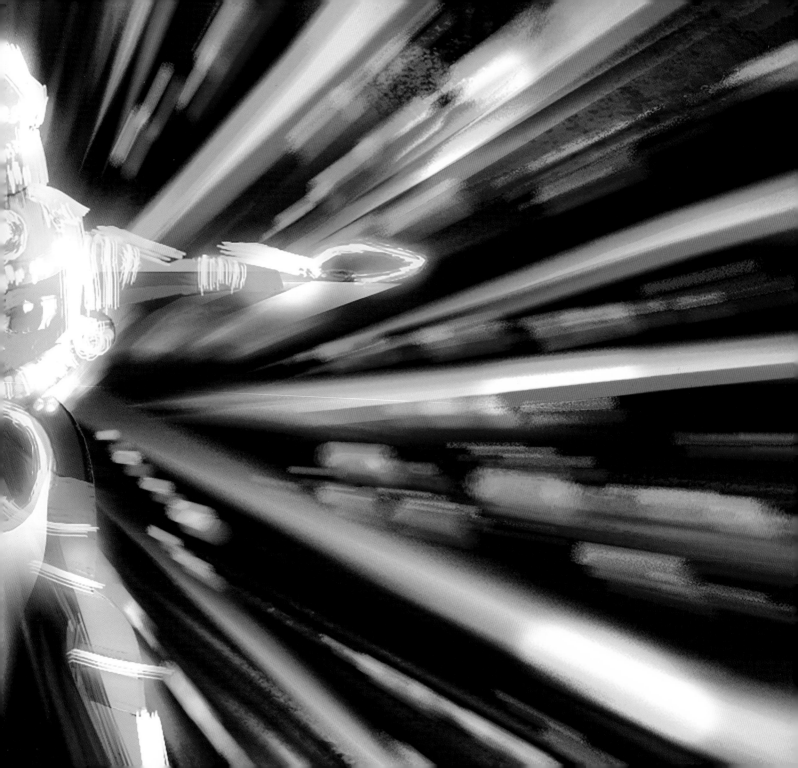

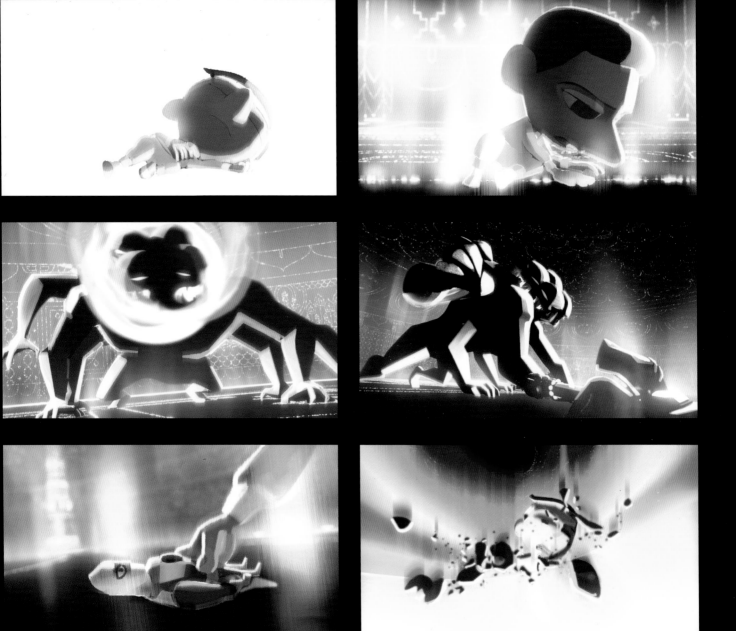

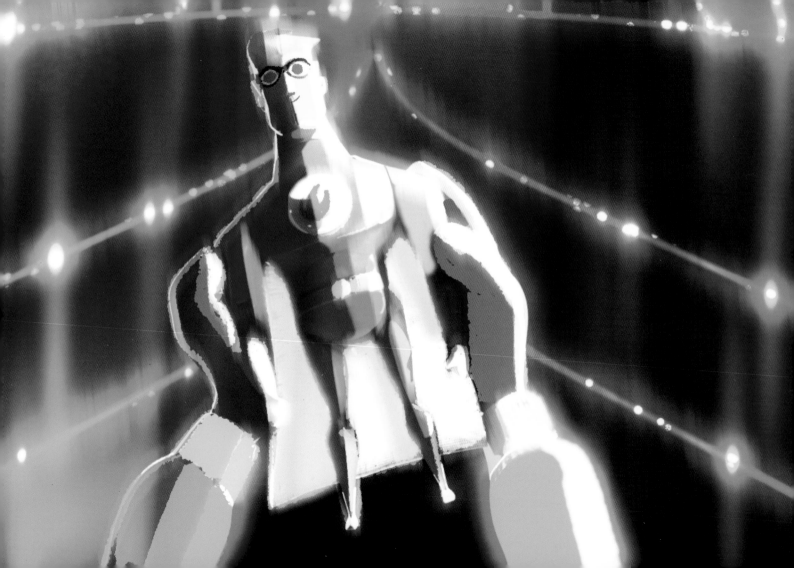

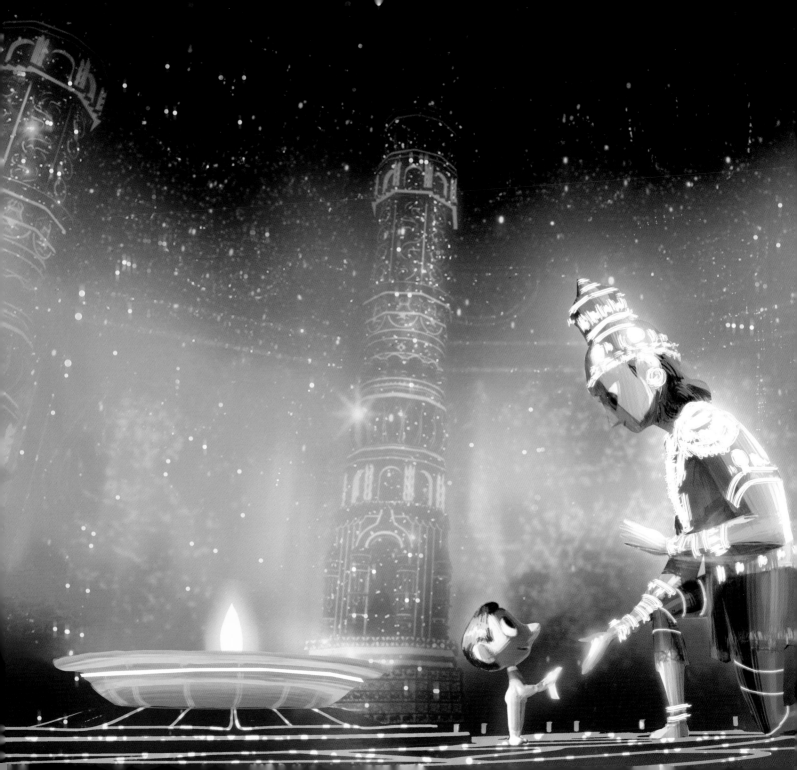

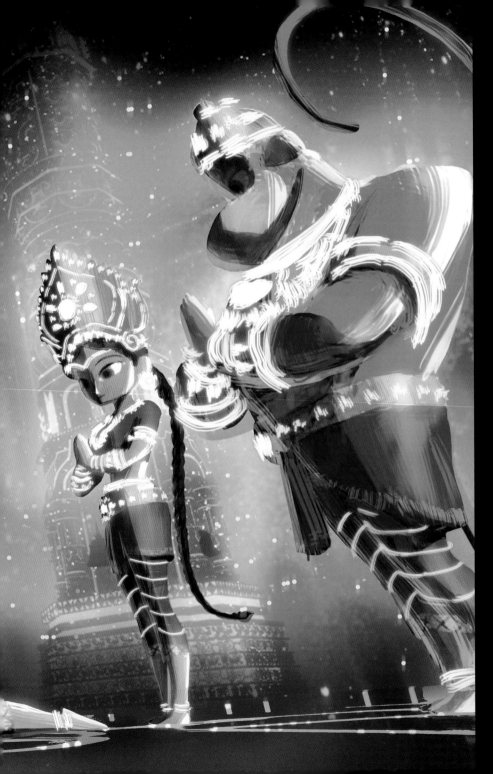

Our aim was for a colorful, magical, and stylized image. The departure from reality into the magical and ethereal gave us the freedom to push the lighting to extreme levels. We layered images of temple contours, star fields, and auroras to create the architectural details of the temple. Auroras revealed the temple walls and dictated the colors in the surrounding areas while glowing stars enhanced features like temple columns, reliefs, and wall details. We hoped to create a magical environment where light reveals this dream sequence without overpowering or confining the characters' actions.

AIRTON DITTZ, LIGHTING LEAD

One of my favorite things about my job is collaborating with the technical departments. We all understood that it was going to take much cooperation and communication between Art and Technical to achieve the unique look that Sanjay wanted, especially for Act 2. Oftentimes, paintings are done to show a proof-of-concept: to demonstrate that the ideas being discussed are attainable. The Lighting, Shading, and Visual Effects departments then use these paintings as visual targets to help them achieve the desired look. In this particular painting, Visaul Effects may pay attention to how the starry background pulses and moves about, while Shading and Lighting may respond to how light and shadow shapes fall on characters' faces.

PAUL ABADILLA, LIGHTING DESIGNER

Paul Abadilla (digital paintover) and Airton Dittz (lighting); digital

117

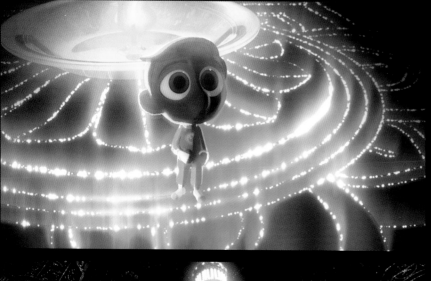

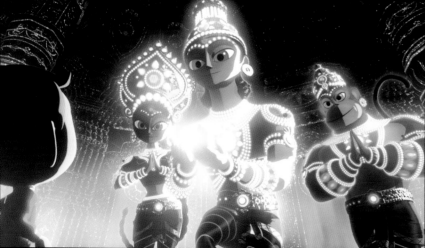

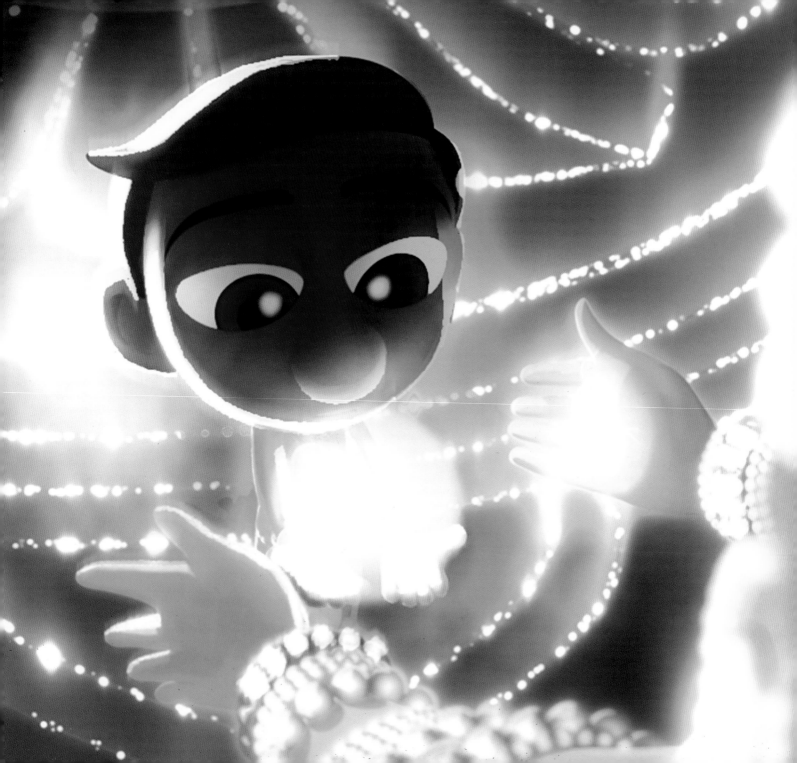

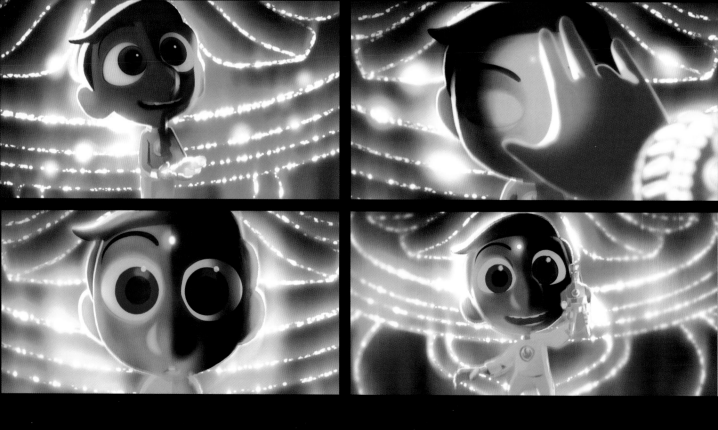

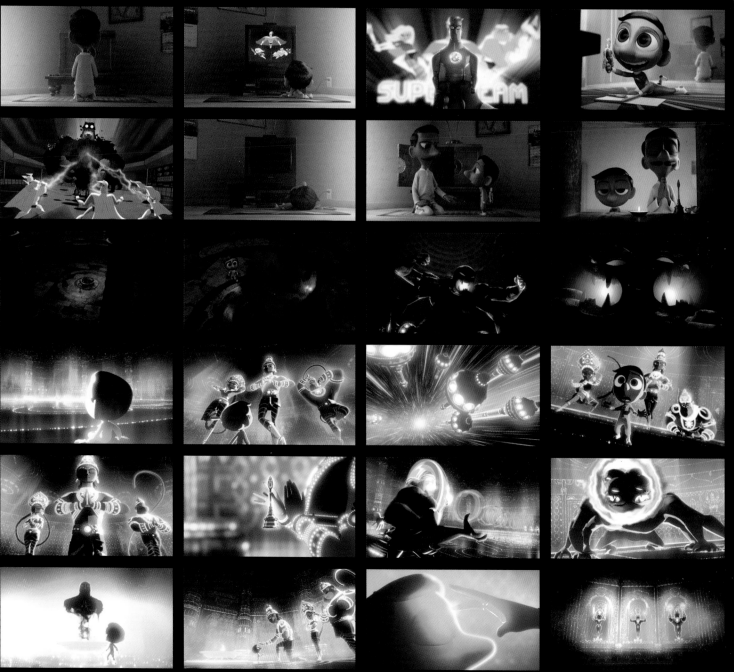

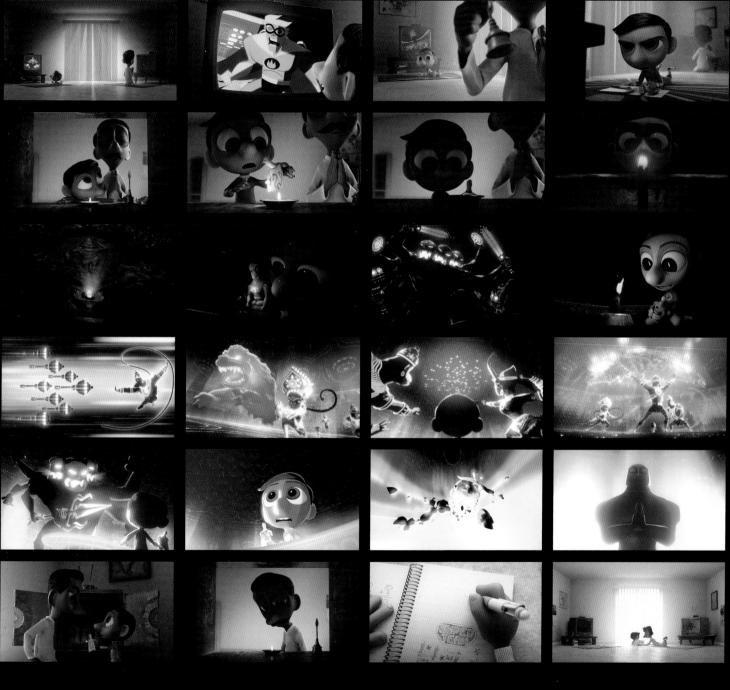

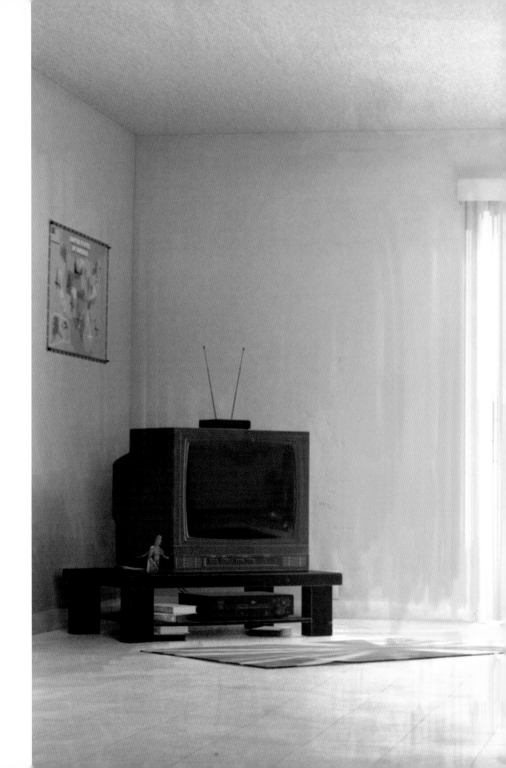

Paul Abadilla (digital paintover)
and Jae Kim (lighting), digital

124

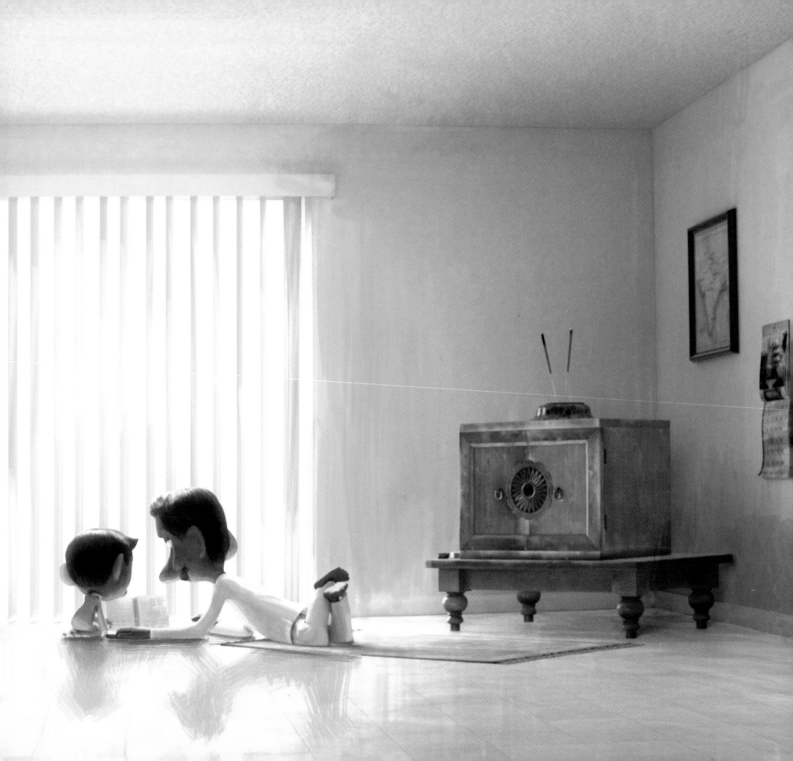

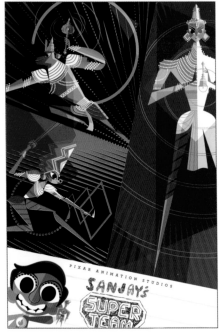

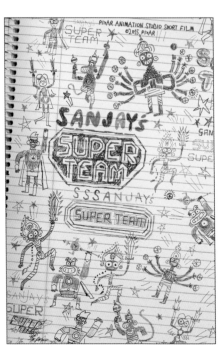

TOP LEFT
Sanjay Patel, digital

TOP RIGHT
Chris Sasaki and
Craig Foster, digital

BOTTOM LEFT
Sanjay Patel, digital

BOTTOM RIGHT
Sanjay Patel and Craig
Foster,
pen and digital

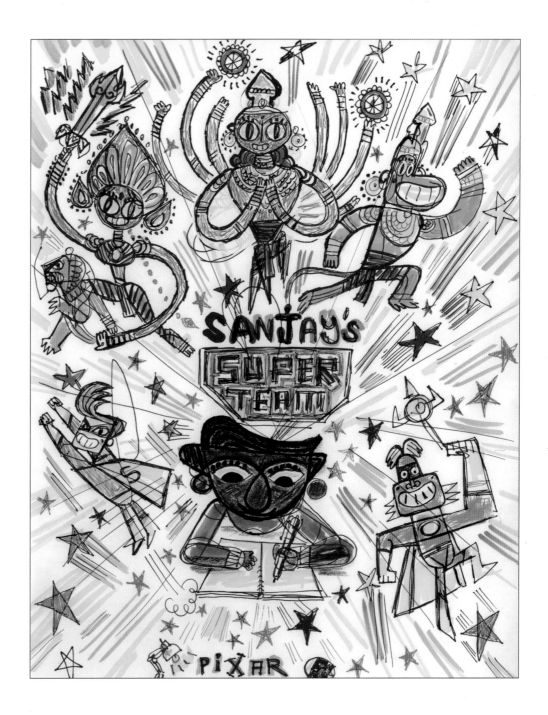

RIGHT
Sanjay Patel,
marker, pen, and
colored pencil

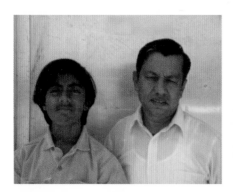

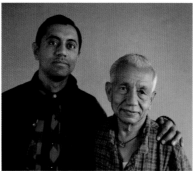

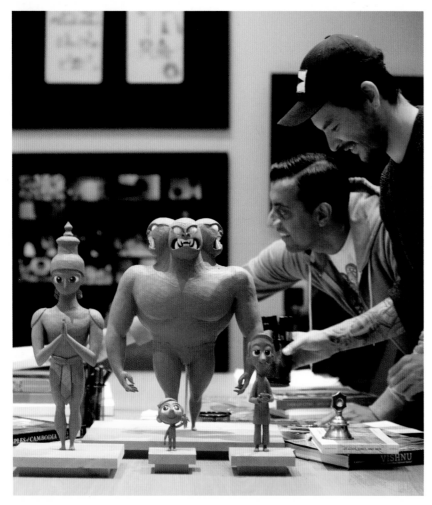

TOP
Photographs by **Amul Patel**
Sanjay Patel and his father, Gopalji M. Patel,
c. 1985, 2013.

LEFT
Photograph by **Deborah Coleman**
Sanjay Patel and Chris Sasaki at work in the
Super Team art room.

ACKNOWLEDGMENTS

As this is the first *Art of* book dedicated to a single Pixar short film, we have many layers of gratitude to express. First and foremost, we owe much to the Pixar short film program, which enables what has sometimes been called our "love letters to the art of animation." Pixar has followed through on a longstanding commitment to produce a short film to precede each of our feature films since *Toy Story*. These films have been invaluable to the studio as a test bed for new technology and new ideas, as well as a proving ground for rising talent. *Sanjay's Super Team*, Pixar's seventeenth original short film, benefited tremendously from having access to the unparalleled resources and talent of this studio. We are particularly grateful to the foresight of John Lasseter and Ed Catmull who, in making this commitment, have sown the seeds of the company's future. Gratitude goes doubly to John Lasseter who recognized Sanjay's potential and offered him this tremendous opportunity, as well as to Pixar President Jim Morris who helped Sanjay understand how it would be possible to realize his own, very personal, artistic vision here at the studio.

Over the course of this film's development, Sanjay worked with a small but essential team of artists who gave the short its visual signature. The astonishingly talented production designer Chris Sasaki's hard work and great taste is in every frame of the film. Much of this book centers upon his work, and that of the team he led. Development executives Mary Coleman and Kiel Murray patiently helped Sanjay weed through a multitude of ideas and asked all the right questions to move him towards this story. Story supervisor Max Brace gave Sanjay the seed of confidence to tell his story, and veteran story artists Jeff Pidgeon and Tony Rosenast provided guidance and mentorship. Film editor Kevin Rose-Williams expertly crafted storyboards into succinct reels that expanded into yet another dimension with the addition of brilliant sound design by Justin Pearson and a haunting score by composer Mychael Danna. Technical production was led by Darwyn Peachey who meticulously ticked off milestone after milestone.

After locking our approved story reels, we were still lacking dynamic action until camera supervisor Arjun Rihan and his team got their hands on the cameras. Animation felt like a breeze thanks to calm and expert animation supervision by Royce Wesley. Lighting supervisor Charu Clark and visual effects supervisor Bill Watral worked as a dynamic duo, synthesizing a truckload of complex visual ideas. We never missed a beat thanks to three production superstars: Dallas Kane, Pamela Darrow, and Rachel Raffael, who each kept a dozen plates spinning with unfailing grace and enthusiasm. Of course, there are dozens more unnamed here that deserve and receive our undying gratitude.

Most importantly, this is a book, and as such, the biggest acknowledgments go to those who worked tirelessly to turn this mountain of art into a beautiful and meaningful visual narrative. As such, we would like to acknowledge the too often thankless efforts of the Pixar publishing team: Molly Jones, Kelly Bonbright, Deborah Cichocki, Shiho Tilley, and Karen Paik. Extra special thanks also goes to the team at Chronicle Books. Senior editor Emily Haynes acquired Sanjay's very first book in 2005 and saw then what would take Pixar another seven years to see: a boy with a big nose, a love of Hindu deities, and a story to tell. Perhaps their most masterful work together so far has been their son, Arjun. Also at Chronicle, Lia Brown guided the book through the many passes of review and kept the schedule on track, and Michelle Clair contributed her essential production experience to make sure the final book came together perfectly. Last, but not least, to Liam Flanagan and Neil Egan, the design duo that did all the heavy lifting: thank you for turning our jumble into a coherent work of art.

Sanjay Patel
Writer and Director, *Sanjay's Super Team*

Nicole Paradis Grindle
Producer, *Sanjay's Super Team*

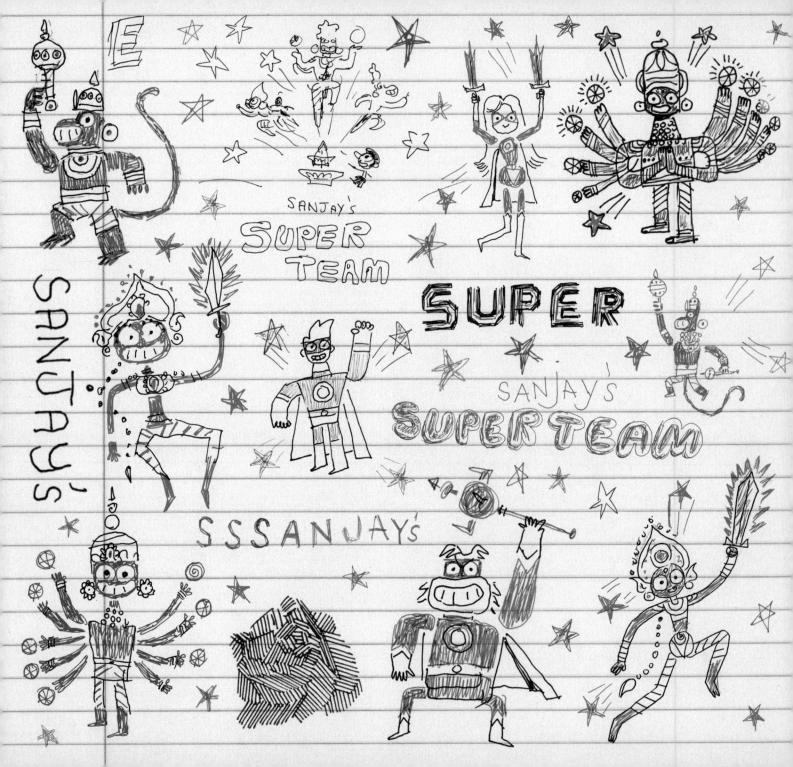